IMAGES
of America

THE EAST RIVER

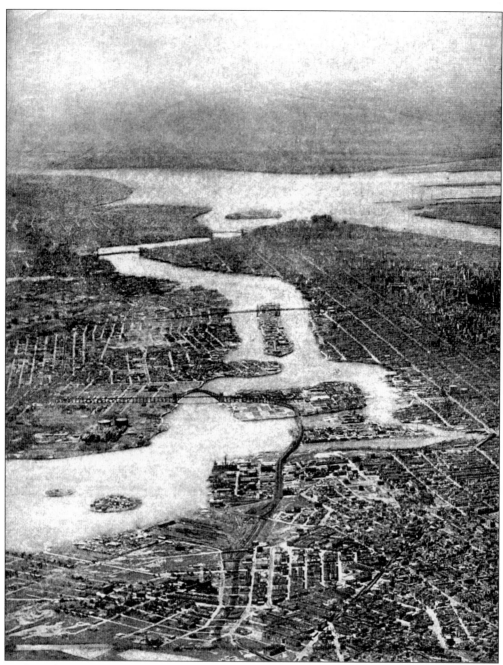

Looking downriver from a position above the Bronx, this unusual 1931 aerial view shows the great sweep of the East River through the heart of New York. From bottom to top are the Brother Islands, Randalls Island, Wards Island, the Hell Gate Bridge, Roosevelt Island, Queensboro Bridge, the bridges to Brooklyn, and Governors Island. The Triborough Bridge has yet to be built. (Courtesy Regional Plan Association.)

IMAGES
of America

THE EAST RIVER

Greater Astoria Historical Society,
Erik Baard, Thomas Jackson,
and Richard Melnick

ARCADIA

Copyright © 2005 by Greater Astoria Historical Society, Erik Baard, Thomas Jackson, and Richard Melnick
ISBN 0-7385-3787-X

First published 2005

Published by Arcadia Publishing,
Charleston SC, Chicago IL, Portsmouth NH, San Francisco CA

Printed in Great Britain

Library of Congress Catalog Card Number: 2004117972

For all general information, contact Arcadia Publishing:
Telephone 843-853-2070
Fax 843-853-0044
E-mail sales@arcadiapublishing.com
For customer service and orders:
Toll-free 1-888-313-2665

Visit us on the Internet at www.arcadiapublishing.com

On the cover: Josef and May Svab, with Bessie the dog, sit on a pile of rocks under the Hell Gate Bridge around 1923. (Courtesy Marie Blanda.)

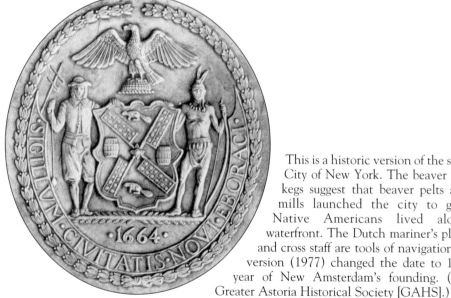

This is a historic version of the seal of the City of New York. The beaver and flour kegs suggest that beaver pelts and tidal mills launched the city to greatness. Native Americans lived along the waterfront. The Dutch mariner's plumb line and cross staff are tools of navigation. A later version (1977) changed the date to 1625, the year of New Amsterdam's founding. (Courtesy Greater Astoria Historical Society [GAHS].)

CONTENTS

ACKNOWLEDGMENTS

The East River touches the souls of many. This is evident by the groups, associations, and individuals who came out in support of this venture. Without them, the book would only tell part of the story.

Thanks go to the following: Judith Berdy, Robert Biliski Jr., Marie Blanda, the Bronx County Historical Society Research Library (Dr. Gary Hermalyn and Lloyd Ultan), the Bronx River Alliance (Stacey Royal), the Brooklyn Bridge Park Conservancy (Virginia Terry), Frank Carrado, Joseph and Concetta Cascio, Tom Connolly, Cyberharbor of TreeBranch Network, Bruce Dearborn, Bernard Ente, Dave Frieder, Etienne Frossard, Granard Associates/F. W. Duffy, Steven Greenfield, Kaufman Astoria Studios (David Domena and Elaine Ferranti), Matt LaRose, Stephen Leone, the Long Island City Business Development Corporation (Gayle Baron and Dan Miner), Louis Mancuso, Steven Melnick, the Metropolitan Waterfront Alliance (Carter Craft and Loren Talbot), Claire and Ruth Meyerhoff, Brian Merlis, Andrew Motta, MTA Bridges and Tunnels Special Archives (Laura Rosen), NASA, the Naval Historical Center, the New York Botanical Garden (Susan Fraser, Melissa Jackson-Schuler, Marie Long, and Madeline Scherb), the NYC Department of Correction and NY Correction History Society (Tom McCarthy), the NYC Housing Authority, NYC Kayaker, the NYC Municipal Archives (Ken Cobb), NYC 2012 (Christine Ong), the Queens Chamber of Commerce, Eric Pitfick, Poppenhusen Institute (Susan Brustman), the Queens Borough Public Library (John Hyslop), the Regional Plan Association (Jeffrey Soffin), the Roosevelt Island Historical Society, Shuli Sadé, Vincent Seyfried, Carson Sheiderman, Judy Shimkus, SilverScreen Marine (Adam Brown), Robert Singleton, Antonia Slagboom, Socrates Sculpture Park (Lisa Gold), the South Street Seaport (Norman Brouwer and Jeff Remling), Bob Stonehill, Debbie Van Cura, and Daniel Zirinsky.

Special thanks go to Robert Singleton and Debbie Van Cura of the Greater Astoria Historical Society for their collections, contributions, tutelage, criticisms, and support. Without them, this book would not have been possible. Thanks also go to Michael McDonald of ImageMaid for scanning and formatting the images.

While researching, the following resources were crucial: *Battle of the Slums*, by Jacob Riis; *Brooklyn Eagle* (1916); *Brooklyn Navy Yard*, by Thomas F. Berner; *Encyclopedia of New York City*; *History of the City of Brooklyn*, by Henry R. Stiles; *Leslie's History of Greater New York*, Vols. 1&2; *Ninth Annual Report of the Commissioners of Public Charities and Corrections* (1868); *On Old New York*, by Thomas A. Janvier; *Rise of New York Port*, by Robert Greenhalgh Albion; *South Street*, by Richard McKay; *The Story of the Bronx*, by Stephen Jenkins; *Valentine's Manuals*; *Waterfront*, by Phillip Lopate; and *Heartbeats in the Muck*, by John Waldman.

For more information, visit the companion Web site at www.eastrivernyc.org.

INTRODUCTION

It avails not, time nor place—distance avails not,
I am with you, you men and women of a generation, or ever so many generations hence,
Just as you feel when you look on the river and sky, so I felt,
Just as any of you is one of a living crowd, I was one of a crowd,
Just as you are refresh'd by the gladness of the river and the bright flow, I was refresh'd.

—Walt Whitman, from "Crossing Brooklyn Ferry"

The East River is New York City's premier waterway. These waters set iconic scenes in familiar culture, from the opening passage of *Moby Dick* to countless shots in films and television shows today. But more importantly, its 16 miles thread together stories and sights from daily life as diverse as the metropolis it sustains.

The river might more accurately be called the Gotham Strait. Atlantic tides jostling through its narrow channels bedeviled sailors, starting with the Dutch explorer Adriaen Block in 1614. He gave its midway point the name *Hellegat*, meaning "bright passage." But as a place of whirlpools and dangerous rocks, the anglicization that stuck was Hell Gate.

It is fitting that the river's center point should bear such a macabre name. After all, the river has a strangely alluring dark side that complements urban grit and mystery. Years after the Revolutionary War, retreating tides on the Brooklyn shore revealed the bleached bones of patriots who had died aboard British prison ships in Wallabout Bay. In 1904, more than a thousand souls were lost when the *General Slocum* steamboat caught fire in the river. Mob hits—both real and fabled—turned the river's general name into a shorthand threat. Its islands, surrounded by powerful currents, served through the centuries to imprison the city's criminals, to house its insane in brutal asylums, and to quarantine its diseased, including the infamous Typhoid Mary.

Despite all this, the river is foremost a source of life. Its rich fish stocks and salt grasses once fed Native Americans, European settlers and their cattle, and its tidal energy swept through marshes to turn mills on Dutch colonial farms. Piers bristled with tall ships, as the port became a center of world trade and shipbuilding. Today, Hindu and Yoruba worshipers gather at shorelines where Native Americans once prayed and colonists baptized. An ecological renaissance is drawing recreational boaters back to the water.

Just as the people who line the river have changed, so has the river itself. It has been cinched by landfill and sea walls and dredged for shipping. The most powerful manmade explosion before the atomic age was done here in order to clear the reefs of Hell Gate. Now 13 tunnels cross below the riverbed as the spans of eight world-class bridges loom over it. Airport runways stretch out into the river where pioneering seaplanes like the *Yankee Clippers* skimmed the surface. But the true joys of the East River—the unique blending of natural forces and cosmopolitan verve—are timeless.

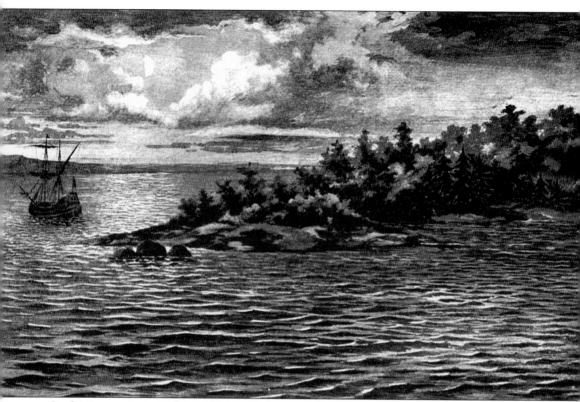

In this imaginative rendering, Henry Hudson's *Half Moon* is anchored off lower Manhattan in 1609. A few years later, a small trading station was set up. The rocks at the point were called *Kapsee* by the Manhates Indians. The original shore ran along the present-day State and Pearl Streets, the latter named supposedly for the heaps of shells lining its route. (Courtesy GAHS.)

One

NATURAL FEATURES

Like the immigrants who come to live alongside it, the East River is a new arrival in geological terms. Global warming 11,000 years ago melted the Wisconsin glacier, swelling the Atlantic Ocean. Seawater muscled its way between a formidable wedge of schist and two huge dirt piles deposited by the scraping edge of what was a miles-thick continental ice sheet. A knobby expanse on the coast of North America, cleaved by the tidal strait called the East River, was transformed into Manhattan and Long Island. The East River is essentially an arm of the ocean.

Paleo-Indian hunters, following caribou herds and other big game grazing at the heels of the retreating glaciers, might have been chased from their camps by the advancing waters. Their descendants, however, came to depend on the fish stocks of the East River and a rich ecosystem centered on the marsh grasses of its wetlands, creeks, and coves. Freshwater ponds, called kettles, trickled into the salty strait, along with the one true river in New York City: the Bronx River.

Though the river is life sustaining, it can also be dangerous. Mariners passing through must brave sometimes fierce currents, most famously at Hell Gate. The East River is chaotic and choppy at this confluence of waters from the Upper Bay, the Long Island Sound, and the Harlem River (also a tidal strait and not a true river), and the way was crowded with rocks and reefs. Even the Earth's crust beneath Hell Gate is in flux. There lies a sliver of Cameron's Line, one of North America's still trembling geological faults.

So far, however, the greatest jolt at Hell Gate was caused by human ingenuity. Civil engineers bent on sapping the confluence of some of its 10-knot hellishness blasted away hazardous rocks and shoals and widened the channel. One of the detonations, on October 10, 1885, was the largest intentional manmade explosion before the atom bomb.

Industrialization was catastrophic for wildlife in and along the East River, but since the 1972 Clean Water Act, the presence of toxins has plummeted. The waterway is enjoying a renaissance, though flora and fauna observed here are now as likely to be transplanted as indigenous. Primitive creatures like shellfish and worms were the first to return, followed by many species of birds and fish. In fact, life in the East River is more genetically diverse than in the world's great coral reefs. Even aquatic mammals seem to be making reconnaissance swims up the East River to check out the revival. Harbor porpoises have been spotted and seals are reported to sometimes sun themselves at the foot of the Williamsburg Bridge, on Belmont Island, and at the Flushing marina. A manatee from Florida swam through in 1995. Whales have not been spotted yet, but they are swimming closer to New York Harbor in recent years than for most of the 20th century.

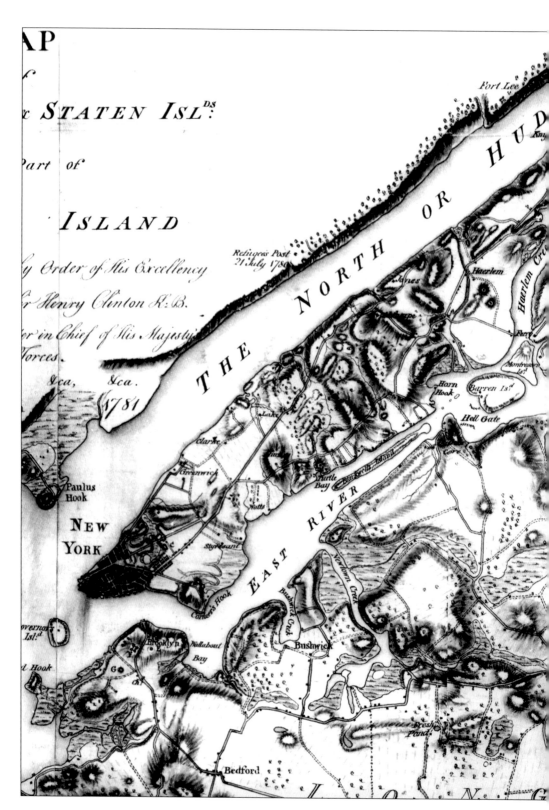

AP

of

r STATEN ISL.^{DS}

Part of

ISLAND

y Order of His Excellency

r Henry Clinton K.B.

er in Chief of His Majesty's

Forces.

&ca, &ca.

1781

THE NORTH OR HUD

Fort Lee

Refugees Post
21 July 1780

Haerlem

Haerlem Cree

Jones

Montresors Isl.

Horn Hook

Barren Isl.

Hell Gate

Lake

Clarke

Turtle Bay

Black Wells Island

Greenwich

Watts

EAST RIVER

Paulus Hook

NEW YORK

Stony Island

Corlaer's Hook

Vanhorn Creek

Governor Isl.

Brooklyn

Wallabout Bay

Bushwick

Bushwick Creek

Bedford

Fresh Pond

L O N G

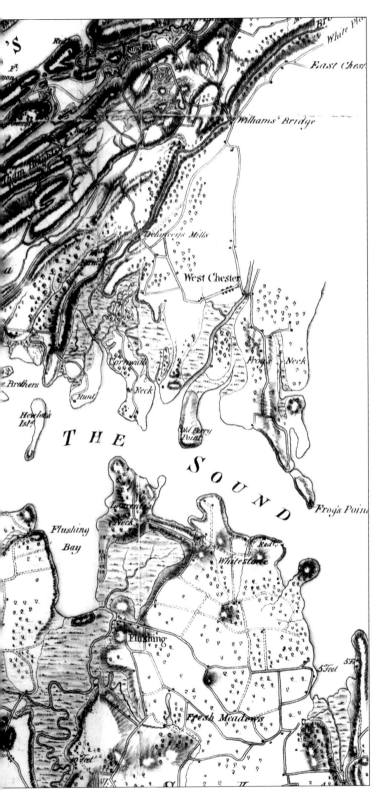

This map, created during the last days as an English colony in the 1780s, depicts many of the primordial topographical features of the East River. High ground, marshland, creeks, and inlets along the river show a varied coastline before being land-filled, dredged, and bulk-headed. The following is an inventory of some names, their modern equivalents in parentheses: Horn Hook (Gracie Point), Laurence's Neck (College Point), Cornwalls Neck (Clasons Point), and Blackwells (Roosevelt), Barren (Wards), Montresors (Randalls), and Hewlet's (Rikers) Islands. Quaint spellings abound. The Bronx, then part of Westchester County, had "Haerlem" Creek, "Morrisania," and "Bronks" River. Compare this map to page 116. (Courtesy Carson Sheiderman.)

The Collect Pond (from *Kolch*, meaning "small body of water" in Dutch) was near modern Centre Street. In 1796, it witnessed a demonstration of the first experimental steamboat. Although once teeming with fish and touted as the finest source of fresh water in lower Manhattan, by the Revolutionary War it was a dump for refuse and sewage. In the early 1800s, it was filled in. (Courtesy GAHS.)

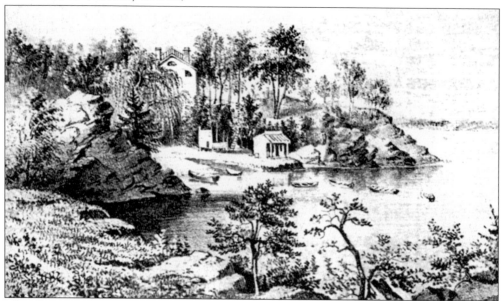

The derivation of Turtle Bay's name is uncertain. It was variously described as harboring a colony of turtles, or as a corruption of *Deutel* Bay, a Dutch word meaning either "bent blade" or "bowling pin," an allusion to its shape. This quaint 1853 view shows the last years of both the bay and the adjoining Beekman mansion. Today, the United Nations complex stands near here. (Courtesy GAHS.)

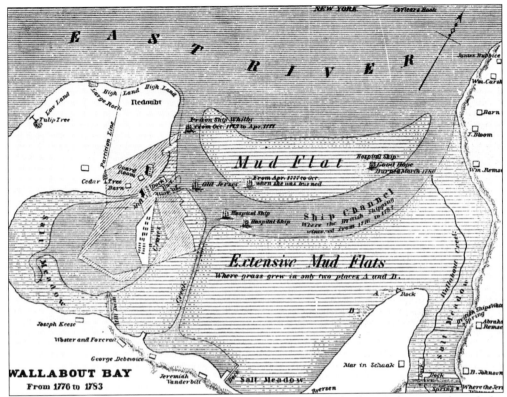

One yarn claims that the name Wallabout is derived from "whale about," the point that whales turned back into the bay after hearing the Hell Gate roar in the distance. Actually, a nearby Walloon colony was called *Waal-Bogt* by the Dutch, meaning "bay of foreigners." During the Revolutionary War, thousands of Americans died here in British prison ships. Later, this became the site of the Brooklyn Navy Yard. (Courtesy GAHS.)

This rare image of the rich clay on Newtown Creek at the Brooklyn-Queens border (*c.* 1883), was taken near Pottery Beach in Greenpoint, an early home of the American pottery industry. (Courtesy GAHS.)

In hidden corners of the East River, such as this pond at Dutch Kills, tidal mills turned corn and wheat into meal and flour. Other inlets included Sunswick Creek and Jackson Mill Creek in Queens, English Kills and Whale Creek in Brooklyn, Morrisania Creek in the Bronx, and Sawmill Creek in Manhattan. (Courtesy GAHS.)

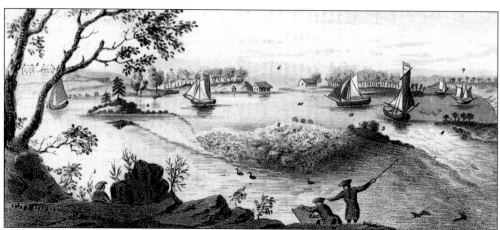

One of the earliest views of Hell Gate, this 1775 engraving looks east from Hoorn's Hook (today's Gracie Mansion). To the left is Morrisania in the Bronx. The Hell Gate was a whirling cauldron whose features had colorful names like the Gridiron, Mill Rock, Hog's Back, and Frying Pan. During the Revolutionary War, the HMS *Hussar* sank nearby with a reported fortune in gold that remains lost. (Courtesy GAHS.)

14

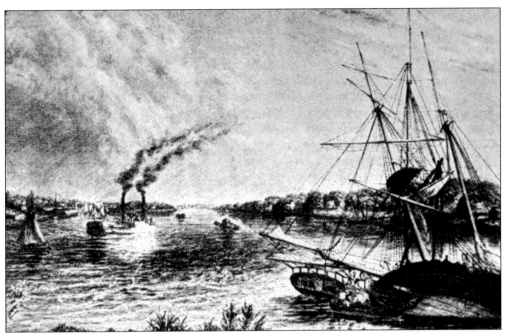

The Hell Gate is captured in this *c. 1846* view from Wards Island. In the foreground is the schooner *Lexington* of Kennebeck, and stranded on Rhinelander's Reef in the distance is the brigantine *Evelina* of Halifax. Here, lethal tides and jagged reefs damaged or sank thousands of ships. The Hell Gate Pilot's Association was formed to help craft through the most dangerous passage of New York's harbor. (Courtesy GAHS.)

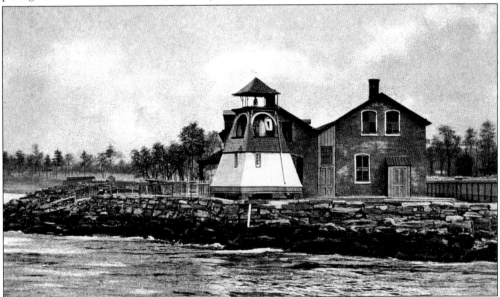

As if Hell Gate were not treacherous enough, fog often blanketed the river. The Hell Gate Electric Lights, one of the tallest such structures in the world, were turned on in October 1884, but river pilots found that the lights blinded them, making the task of guiding boats all but impossible. The lights were quickly replaced by a fog bell at Hallett's Point (pictured). (Courtesy Bob Stonehill.)

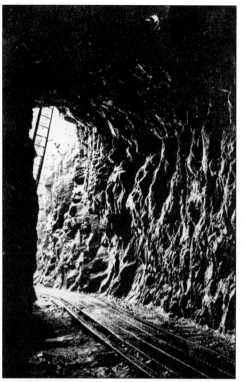

Engineers decided to remove Hallett's Reef by digging a series of subterranean tunnels from the shoreline to the middle of the Hell Gate. Explosives were packed next to the pillars that held up the honeycomb of passages. After the tunnels collapsed from the detonation, the rubble was grappled to the surface. This photograph, taken in 1876, shows one of the manmade tunnels under the Hell Gate bedrock. (Courtesy Robert Singleton.)

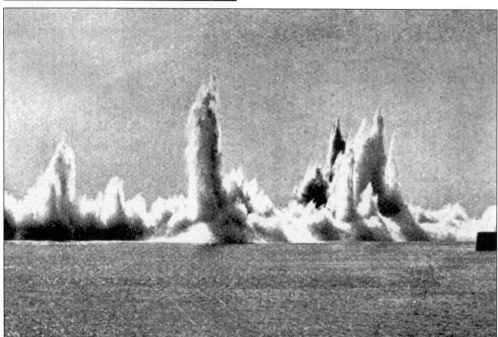

The Hell Gate was so challenging to make safe that the government considered digging a canal between Pot and Hallett's Coves. This destruction of Flood Rock, on October 10, 1885, was the largest intentional manmade explosion before the 1945 atomic bomb. One account claimed it was audible in Trenton, New Jersey. (Courtesy GAHS.)

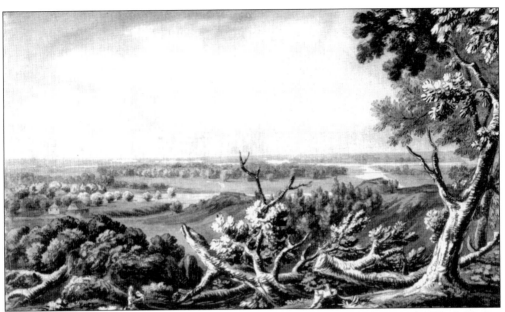

This c. 1777 view looks northeast from a bluff just inside Central Park, near the Block House. Beyond the Harlem plain are Wards and Randalls Islands. To the left is Morrisania in the Bronx, and in the distance, the Hell Gate and Long Island. The image gives a good idea of the original state of the upper East River. (Courtesy GAHS.)

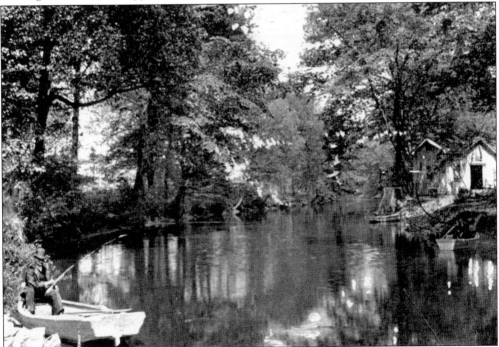

The Bronx River is the only true river in the five boroughs of New York City. It flows from Westchester County through the Bronx into the East River. Looking at the fisherman in his boat on the crystal clear stream, one can almost hear a dragonfly buzzing over the water to complete this late-19th-century gem. (Courtesy GAHS.)

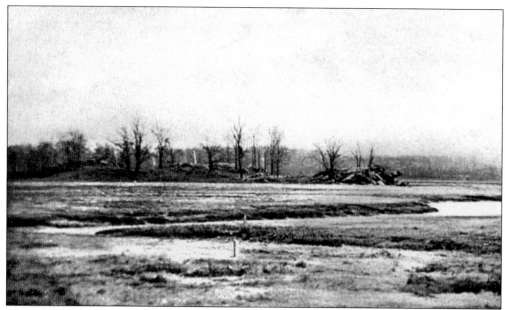

The upper East River is marked by a jagged coastline with numerous islands, peninsulas, and bays whose names echo early landowners like Baretto, Hunts, and Clasons Points in the Bronx, or Willets, Sanford, and Lawrence Points in Queens. This bluff of black gneiss was the Black Rock on Cornell's Neck, mentioned in a deed between Governor Nicholls and Thomas Willett, grandson of Thomas Cornell, in 1667. (Courtesy GAHS.)

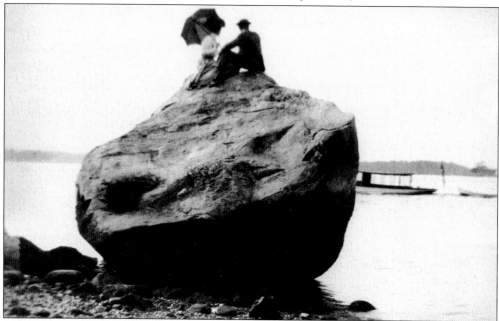

Some claim this glacial erratic, a boulder dropped 12,000 years ago by the last retreating ice sheet, was the White Stone, the namesake for a community in Queens. A Dutch navigational journal from 1673 recorded this now long gone landmark. Natural features on the East River, from Greenpoint in Brooklyn to Oak Point in the Bronx, left their identities in community names. (Courtesy Queens Borough Public Library.)

In the early 20th century, much of the East River had not altered from its original state. This rocky coast at East Elmhurst, just south of LaGuardia Airport, now lies under the Grand Central Parkway. By the 1930s, this highway not only cut off the backyards and sea walls of residents but permanently walled the community from waterfront access except for a narrow, noisy strip of sidewalk. (Courtesy GAHS.)

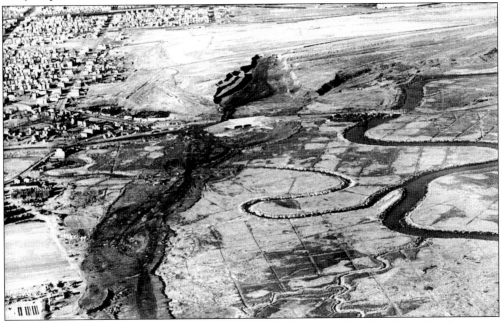

The "Valley of Ashes" made famous in F. Scott Fitzgerald's *The Great Gatsby* awaits transformation into the 1939 World's Fair displaying the "World of Tomorrow." Once a beautiful tidal basin, Flushing Creek drained most of central Queens. By the time this photograph was taken in 1934, the area was the noxious Corona Dumps. Two manmade lakes were created within this park space. (Courtesy MTA Bridges and Tunnels Special Archive.)

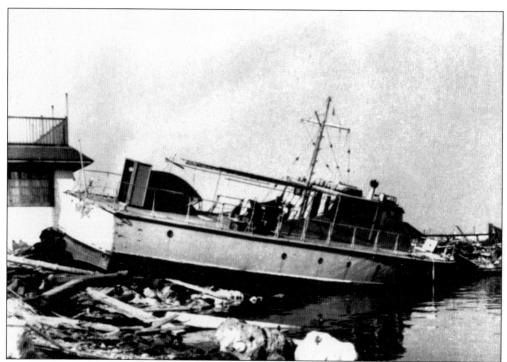

Nature is unremitting as it reforms the East River coastline. When the 1938 hurricane stormed across Long Island, there were 60 fatalities and millions of dollars in damage. The fishing industry was severely crippled, with scores of boats destroyed, including the *Atlantis*, shown here at Muff's Boatyard in northern Astoria. (Courtesy Robert Biliski Jr.)

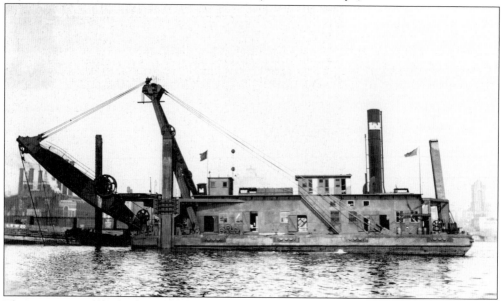

The ecosystem of the harbor is never static; it remains evolving. The dredge *Hell Gate*, shown in 1930, performed the yeoman's task of keeping the harbor waterways navigable and safe. Shifting sand and rock, in continuously reshaping the harbor bottom, create a potential hazard to vessels. Their removal is a constant challenge. (Courtesy GAHS.)

Natural features such as streams, rocks, and trees were included in the property descriptions of early deeds. In 1912, the Spy Oak on Throgs Neck in the Bronx was centuries old, with a trunk whose girth exceeded 20 feet. Tradition held that a British spy was hanged from a branch of this tree and his spirit haunted the area. Local boys, as a prank, would lurk about frightening passersby at night. (Courtesy GAHS.)

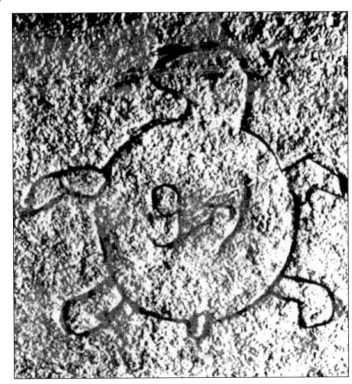

A turtle petroglyph, scraped into the rock with stone tools between 400 and 1,000 years ago, was found recently in the Bronx. The glacial boulder was about 20 feet above a bend in the Bronx River. (Courtesy New York Botanical Garden.)

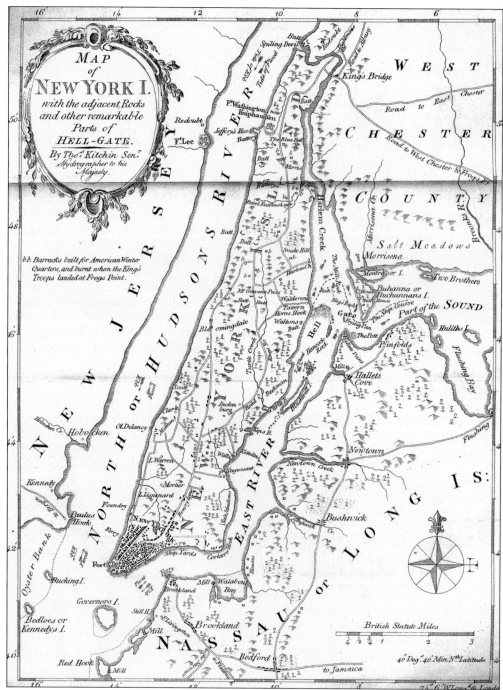

In the Kitchin map of 1778, the skeleton of our modern city begins to take shape. Names on this early map, such as Flushing, Westchester, Morrisania, and Turtle Bay, are familiar today. At this time, the East River was already an important commercial waterway, to which notations such as "Ship Yards" in lower Manhattan, the "Brookland" Ferry in Brooklyn, and numerous tidal mills along the river can attest. (Courtesy GAHS.)

Two
EARLY HISTORY TO 1815

The natural riches of the East River sustained thriving Native American cultures for 11 millennia. Local longhouse villages traded through a network reaching as far as the Caribbean. The first Europeans to settle in New York Harbor also relied on the natural bounty of their new home, but in just a few generations extended the East River's commercial reach to the entire globe.

The Native American cultures of this region worked mostly with wood, from their longhouses to their dugout canoes. As a result, they left few archeological remains. Instead, some of the strongest traces of prior inhabitation are linguistic. The most famous example is *Mannahatta* ("hilly land") from a Native American tribe called the Lenni Lenape. A more ancient echo can be heard at Astoria's Sunswick Beach. That name comes down 3,000 years to us from the proto-Mohican word *Sunkisq*, or "high woman's place." Whether she was a sachem's wife, a sachem in her own right, or a priestess, she probably gathered wetland herbs for medicine, ceremonies, and food.

While some believe the Vikings may have ventured as far south as New York Harbor, it is safe to say that the first significant European settlement was that of the Dutch in the 1620s. A windmill was erected on Manhattan's gustier Hudson River shore, but along the east bank of the East River it was the tidal power that ground grain into flour. Sometimes slave labor was used to sew and reap crops. Salt meadow grass was harvested in the fall and fed to cattle in the winter.

By 1642, a primitive ferry was plying the waters between Manhattan and Brooklyn, and five years later, the Dutch built the first East River pier, at Pearl and Broad Streets. The little boomtown of New Amsterdam attracted both entrepreneurs and smugglers from around the world. The people of the outlying hamlet of Flushing became unlikely heroes for religious freedom when they harbored Quakers in defiance of Governor Stuyvesant's decree that all colonists adhere to the Dutch Reformed Church.

When the British took over and New Amsterdam became New York, they spurred waterfront development by selling offshore water lots in exchange for investment in wharf development. By the close of the 17th century, a powerful merchant class controlled the settlement.

During a bitter Dutch-Indian war, the colony tasted suffering and death on the East River. On both sides, settlements were destroyed and people were massacred as the colony cowered behind New Amsterdam's famous wall. During the Revolutionary War, General Washington crossed the East River in a hasty retreat, and thousands of prisoners died from disease and starvation aboard prison ships moored in it. During the War of 1812, the United States placed forts at both ends, from Manhattan's Battery to Throgs Neck, and erected a blockhouse watchtower on Mill Rock in the already hazardous Hell Gate.

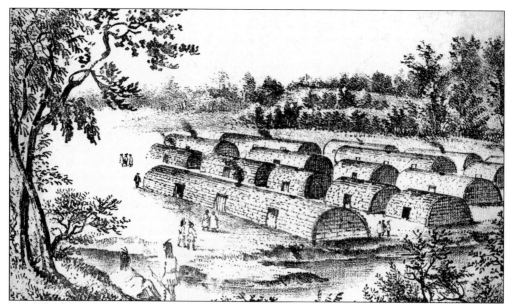

The bark-covered longhouses of the Long Island Indians measured 18 to 20 feet wide and up to 150 feet long. Settlements, fishing camps, and planting fields lined the river from Castle Hill, Clasons Point, and Throgs Neck in the Bronx, the Battery and Harlem in Manhattan, and Bridge Street in Brooklyn, to Maspeth, Pot Cove, and Flushing in Queens. The earliest European settlements were near these native sites. (Courtesy GAHS.)

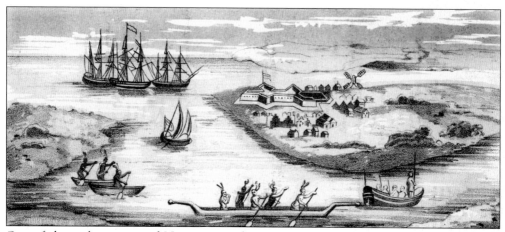

One of the earliest views of *Nieuw Amsterdam*, this was created *c.* 1626 and published in Amsterdam in 1651. It accurately portrays everything, from native dugout canoes to Dutch fleet ships on the East River. Contemporary sources state that most canoes were small but that some were up to 50 feet long and held 10 to 12 people. (Courtesy GAHS.)

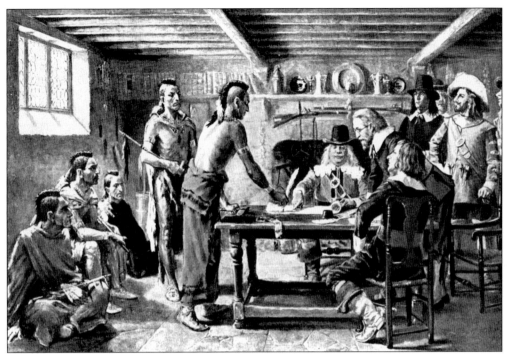

This 1642 treaty between Jonas Bronck, the first European settler (and namesake) of the Bronx, and the Weckquaesgeek Indians was part of a process that gradually extinguished native claims to lands on the river. Native Americans were decimated by disease and overwhelmed by a growing flood of European immigrants. One of their last settlements, in the 1660s, was at Maspeth on the Brooklyn-Queens border. (Courtesy Robert Singleton.)

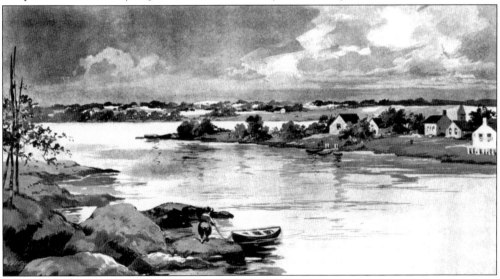

In 1638, the *Nieuw Haarlem* patent awarded the valley north of Central Park and east of Washington Heights to settlers. While Harlem faced the Harlem River, around the bend from the Hell Gate, the grant included Harlem Commons and extended south to 74th Street on the East River. This is an imaginative view of the early Dutch settlement, from Morrisania in the Bronx. (Courtesy GAHS.)

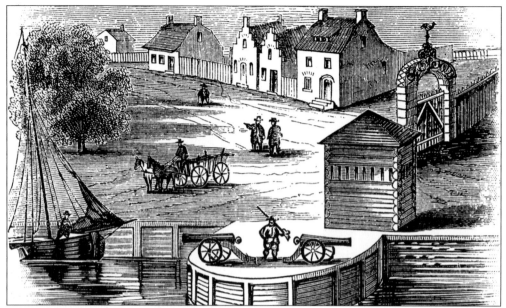

A small wooden wall was constructed *c*. 1653 to defend the inhabitants of New Amsterdam from attacks by Native Americans or the British. In this image, the East River bastion is fortified with a gate, guard, and cannon. Wall Street was laid down along the wall's wagon road, originally called *De Wall Straat* by the Dutch. The wall went untested and was demolished by the British in 1699. (Courtesy GAHS.)

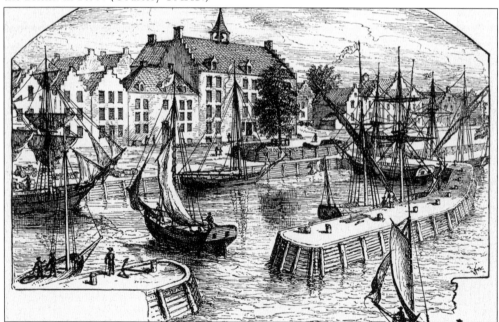

During Dutch administration, the *Stadt Huys* (city house) was located on Pearl Street near Coenties Slip. After much of the city's administrative decisions were made there, the former tavern became New Amsterdam's city hall in 1653 and served in that capacity until 1699. At its front door, the East River's Great Dock was the vibrant center for commerce, business, and trade. (Courtesy GAHS.)

A privateer swaggers ashore in New York in the early days of the republic. One hundred years before, Captain Kidd called the East River his home port. Smugglers such as Humphrey Clay of English Kills (who sailed with Kidd) ensured that customs agents collected only a fraction of duties. Governor Fletcher's reputed leniency to piracy and privateers prompted his recall by the British crown in the late 1600s. (Courtesy GAHS.)

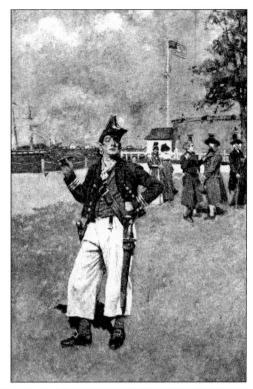

Shown here is one of two granite millstones from a tidal mill located on Dutch Kills *c.* 1648. The millstones were rescued by the Payntar family *c.* 1860, when the Long Island Rail Road razed the mill, and later in 1915 by New York City. Now embedded in a traffic triangle at Queens Plaza North, they are the oldest colonial artifacts in Queens. (Courtesy Steven Melnick.)

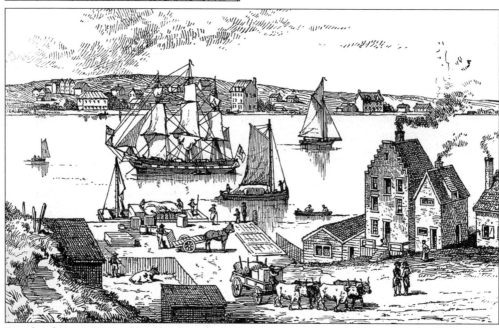

By 1675, the Dutch had lost New York to England. Gov. Thomas Dongan granted New York and the other local townships liberal charters with limited autonomy. However, the colonial administration retained a tight grip on trade privileges, as customs duties were one of the most important sources of income to colonial governments. This is a copy of the 1686 grant confirming Brooklyn township. (Courtesy GAHS.)

Regular ferry service across the East River began as early as 1642 to *Breukelen* (Brooklyn). The earliest ferries were primitive, oar-powered scows and small ships of sail. Steam ferry service was inaugurated in 1814. Rendered obsolete by the many bridges and tunnels across the river, ferries lingered until the 1930s, only to revive again in the closing years of the 20th century. (Courtesy GAHS.)

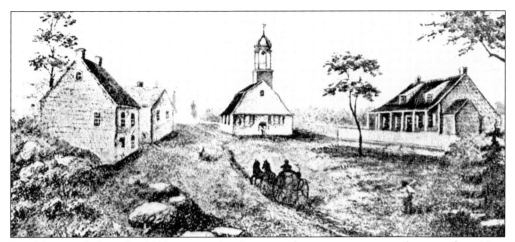

Brooklyn, settled in the 1630s, enjoyed a fortuitous location just across the river from New York. It was not at the heart of Kings County's "five Dutch towns" (that honor went to Flatbush), but the "city of churches," riding on the East River's explosive growth of industry and commerce, found the economic and political clout to absorb its sister towns. This 1776 Dutch church stood on Fulton Street. (Courtesy GAHS.)

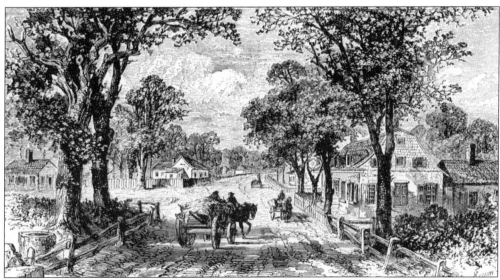

Provincial and quaint, Bedford Corners was a crossroads between Maspeth in Queens County and Brooklyn and Flatbush in Kings County. Nurtured by the fertile land found along the East River's banks, Bedford remained a rural hamlet from the time of its founding (1663) until absorbed into the Brooklyn community of Bedford-Stuyvesant. (Courtesy GAHS.)

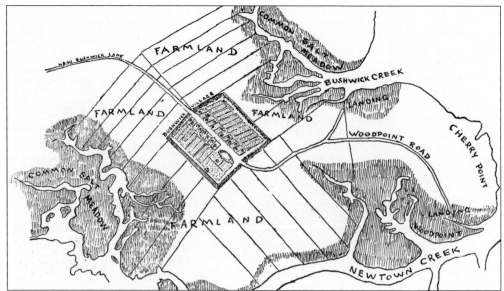

Flushing and Maspeth were settled on the river in the 1640s, but later settlements like Newtown (Elmhurst) in 1652 and *Boswijck* (Bushwick) in 1660 were farming communities somewhat removed from the river (and away from the temptations of smuggling). This map shows historic locations in Bushwick such as Cherry Point and Wood Point (today's Greenpoint), as well as Bushwick, Newtown, and Whale Creeks and Dutch and English Kills. (Courtesy GAHS.)

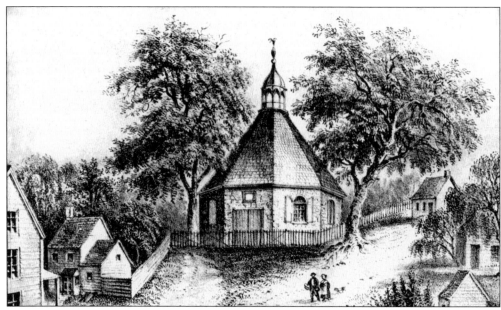

The overlapping claims of Maspeth (later Newtown) and Bushwick provoked bitter fighting, only resolved by marking their boundary late in the colonial period at Arbitration Rock. Destroyed during the Revolution, the rock was replaced and dragged to the approximate spot during the 19th century. Several blocks away, a glacial erratic may mark the earliest boundary. Pictured is Bushwick Church. (Courtesy GAHS.)

This map shows the early layout of Old Flushing Village at the head of Flushing Bay. *Vlissingen* was founded in 1645 and named after a town in the Netherlands. Home to both the Prince and Parson Nurseries, it was the birthplace of the country's horticultural industry. (Courtesy GAHS.)

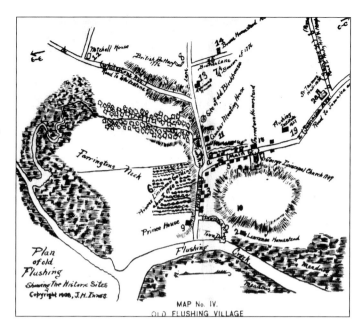

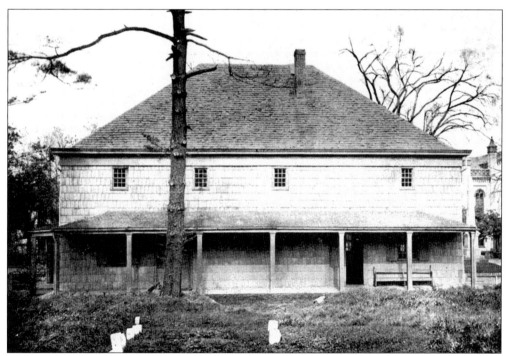

The 1694 Quaker Meeting House in Flushing is the oldest house of worship in New York City. This may have also been the location of Edward Hart's home. Hart, as Flushing town clerk, penned the 1657 Flushing Remonstrance, widely regarded as the blueprint for religious freedom in the United States. He was later given the onerous assignment of customs collector in Flushing. (Courtesy GAHS.)

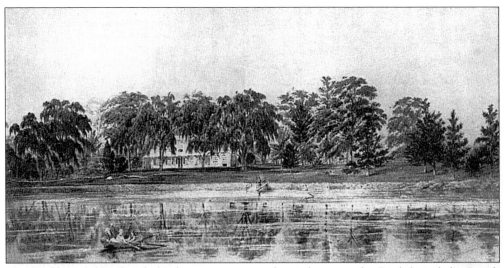

The Waldrons of Harlem helped serve as intermediaries between the English and the Dutch when the British conquered New Netherland in 1664. On the 1778 Kitchin map (page 22), the Waldron property is listed as "Walderons Tavern." Today, this area is the Upper East Side on the East River. (Courtesy GAHS.)

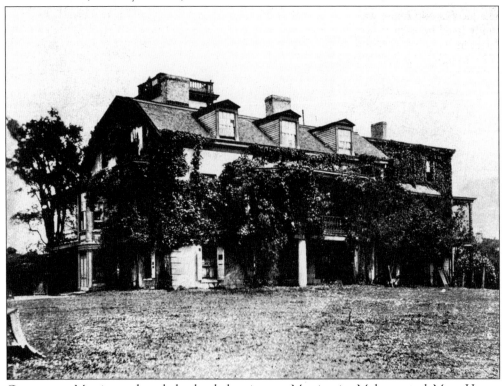

Gouverneur Morris purchased the land that is now Morrisania, Melrose, and Mott Haven c. 1788. He was a half-brother to Lewis Morris, a signer of the Declaration of Independence. Gouverneur served in the Continental Congress and the 1787 Constitutional Convention and as a U.S. senator and American ambassador to France. He suggested that Morrisania would make a fine location for the District of Columbia. (Courtesy GAHS.)

The Jacobus Kip house was built at today's 35th Street and Second Avenue in 1655. The Kip family lived here for nearly 200 years before it was demolished in 1851. After the American defeat in Brooklyn in August 1776, a massive British force landed at Kips Bay on September 15, 1776, to pursue Gen. George Washington and the retreating Americans. (Courtesy GAHS.)

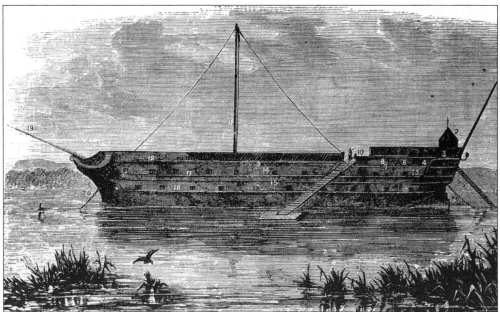

Accounts state that more than 11,000 patriots died in the British prison ships anchored in Wallabout Bay. If this is true, then half of the American casualties during the Revolution occurred there. The dead were thrown into graves along the bay. Eventually disinterred and given proper burial, they now rest at the Prison Ship Martyr's Monument in Fort Greene Park. Shown here is the *Jersey*, the most notorious of prison ships. (Courtesy GAHS.)

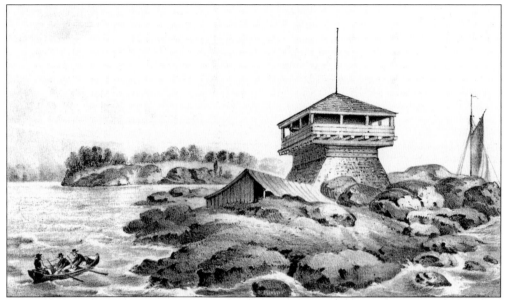

During the War of 1812, New York was vulnerable to attack from the north by way of the East River. A frantic fortification program throughout the city included building a blockhouse for Mill Rock (an island in the Hell Gate), an observation tower overlooking the Hell Gate at 27th Avenue and 14th Street in Old Astoria, and Fort Stevens. (Courtesy Debbie Van Cura.)

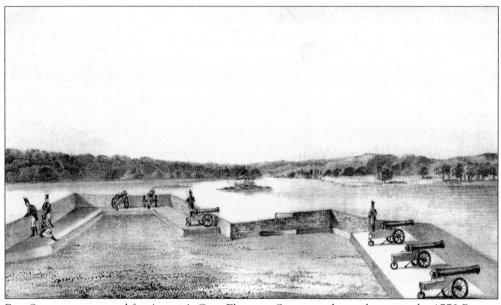

Fort Stevens was named for Astoria's Gen. Ebenezer Stevens, who took part in the 1773 Boston Tea Party as a young man. After the War of 1812, its garrison was reduced to one sergeant. This location was later the Hallett's Point Lighthouse and is now the Whitey Ford (Baseball) Field. Some of the barracks or outbuildings may still remain in Old Astoria Village. (Courtesy GAHS.)

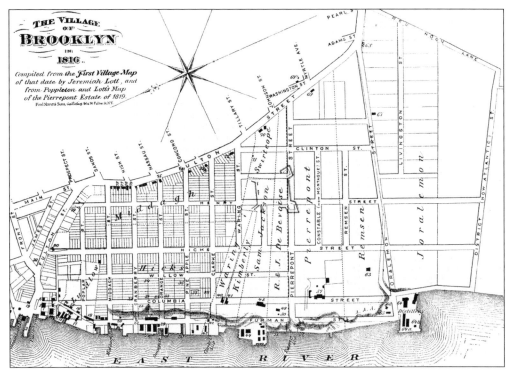

By 1815, with the end of hostilities, conditions were ripe for dynamic growth on the East River. Within a generation, the lower East River was entirely dedicated to shipping, industry, transportation, and development. On April 12, 1816, the state legislature passed an act incorporating Brooklyn. (Courtesy GAHS.)

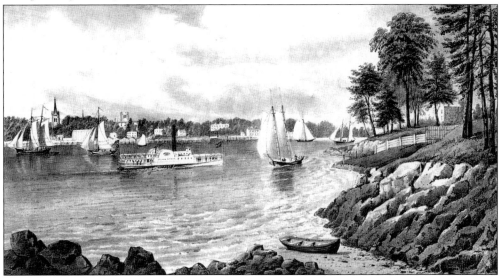

This Currier and Ives print shows Astoria Village from 86th Street in Manhattan. John Jacob Astor, who could see the steeples of Astoria's churches from his estate on the river, donated money to an institute in the community. Grateful citizens renamed Hallett's Cove "Astoria" in his honor. Today, the remains of Old Astoria Village are still visible from Gracie Mansion. (Courtesy GAHS.)

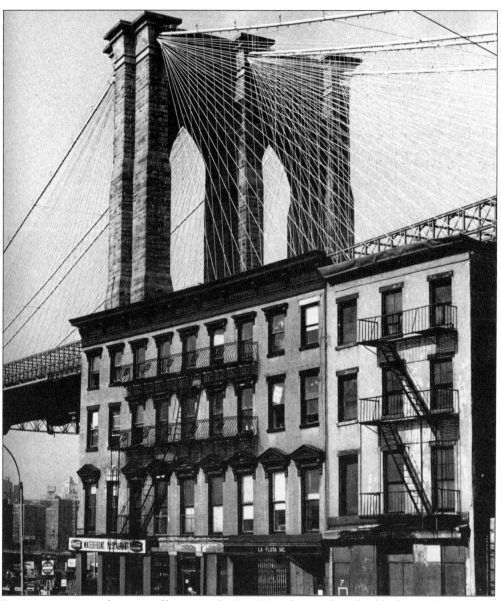

Few images capture the spirit of living on the East River better than this block on Fulton Street, Brooklyn, which once witnessed the flow of traffic from the old Brooklyn ferry. The corner building was a hotel where tenants fell asleep lulled by the constant hum of automobile tires overhead. Gov. Al Smith fondly recalled watching the Brooklyn Bridge going up during his childhood. (Courtesy South Street Seaport.)

Three

LIVING ON THE RIVER

The East River ebbs and flows past many of New York City's most fascinating neighborhoods, whose relationships to the water have changed dramatically over time.

The earliest colonial settlements, like Flushing and Maspeth, stood in the footprints of Native American villages. They also assumed much of the natives' lifestyle, thriving on fishing, hunting, and trading. In time, they brought over cattle, which fed on nutritious marsh grasses. When the Dutch governors of New Amsterdam found that quaint waterside villages were havens for smugglers and pirates, they tried to push new colonists onto farms farther inland. The British experienced this problem, too, with the legendary Captain Kidd, who often put in at Cripplebush (Williamsburg) and Bushwick, Brooklyn. But the attraction of the waterway for fishing, trading, and other vital activities of small town life was too great to shift the population's center of gravity inland by government fiat. Even after the age of sailing ships had passed, wealthy merchants slept near where their money was made, filling tawny "Steamship Row" on State Street.

In time, the economic dynamo of the harbor spawned massive industrialization. Factories, refineries, commercial shipping piers, and power plants mushroomed along the shoreline, pushing downtown Manhattan residential communities along the East River inland after all. Only gang-infested tenement slums remained, such as the notorious Five Points and Gas House District. Perhaps the clearest example of the low regard in which Manhattan's residents held the East River was the 1928 construction of elegant Tudor City; its rear walls had small windows blocking out the view of the slaughterhouses and shanties. Robert Moses, New York City's most influential parks commissioner, nearly severed Manhattan's relationship with the East River when he filled in coves and paved over the shoreline for the FDR Drive.

Wealthy New Yorkers who wanted to enjoy the river throughout the 19th and early 20th centuries instead carved out exclusive waterfront communities farther and farther from the grittiness of the wharves, seeking quietude in places like Brooklyn Heights, Ravenswoods, Astoria, and Malba. In the heart of the city, however, the only major residential developments along the East River were public housing projects, some of which were the largest in North America. The physical conditions were certainly an improvement over the old slums, but crime was still rampant for several decades before ebbing in the 1990s. The projects were also powerful engines of cultural development, spawning the rise of rap music.

Developers, in league with urban planners and politicians, now dream about adding thousands of apartments to the river. Their plans are running into scrutiny by adjoining communities concerned about the impact this would have on their quality of life.

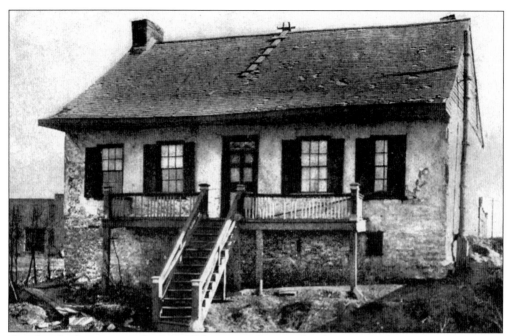

One hundred years ago, the late-17th-century Duryea farmhouse, which stood at the foot of Meeker Avenue near Penny Bridge, was the oldest dwelling on Newtown Creek. Imaginative schoolboys suggested it was used as a fort and the slits in the basement windows were gun ports. The house was torn down in the early 20th century. (Courtesy GAHS.)

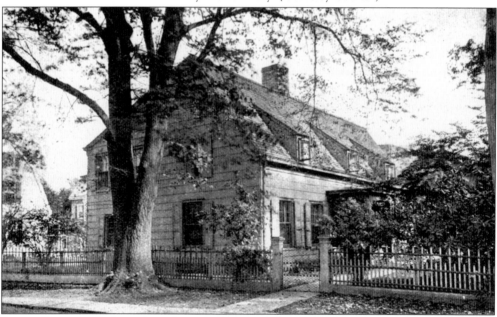

Bowne House in Flushing dates from 1661. John Bowne permitted Quakers to worship in his house in defiance of Governor Stuyvesant, who wanted them banished. Bowne, a merchant from New England, was arrested and sent down the East River to a jail cell in Fort Amsterdam. He demanded a trial in Holland, where he successfully defended his rights and won his freedom. (Courtesy GAHS.)

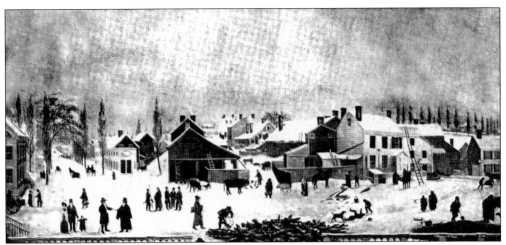

Francis Guy captures an early winter morning in Brooklyn. Real people, drawn from life, go about their chores outside of his window at the corner of Front and Dock Streets. The Brooklyn of 1816, population 5,000, was still a small town. Within 50 years, with a population of 500,000, it had become a formidable rival to New York. (Courtesy GAHS.)

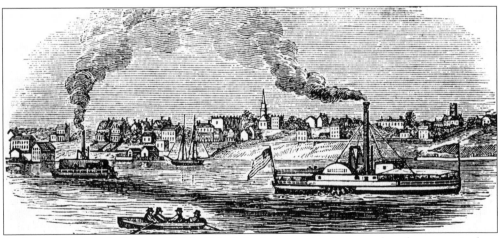

A former haunt of Captain Kidd, Cripplebush grew slowly around a ferry terminal to Manhattan. In 1827, the village was renamed Williamsburg, after local surveyor Jonathan Williams. By 1852 (the date of this print), it was a city of 30,000. Three years later, it was absorbed into the city of Brooklyn. Williamsburg was the birthplace of Pfizer Pharmaceuticals, Standard Oil, and Amstar (Domino) Sugar. (Courtesy GAHS.)

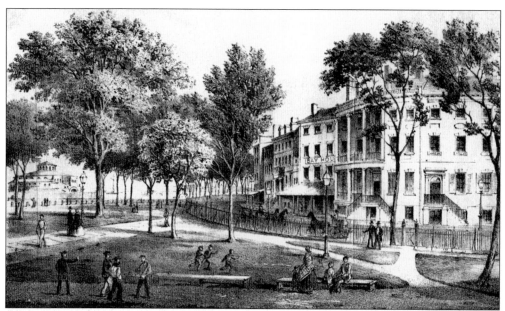

Once called "Steamship Row," State Street was home to counting house merchants and was considered the finest block on Manhattan. A system of signals from a tower on Staten Island, visible from residents' windows, gave information on that day's arriving ships, advance intelligence that was used to their advantage. These buildings later became offices for various steamship companies. (Courtesy Thomas Jackson.)

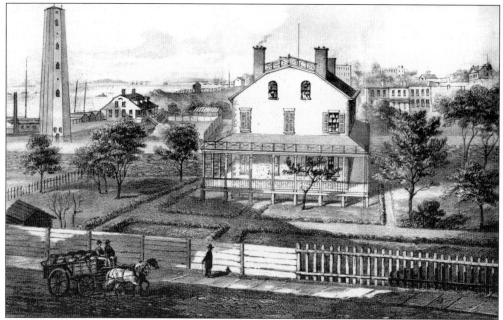

The Brevoort estate, between 54th and 55th Streets near First Avenue, is about to be engulfed by the developing city c. 1865. Shown in the background, the Youle Shot Tower, built c. 1830, made buckshot pellets by dropping molten metal through a screen at its top. The droplets cooled after falling into a pool of water at its base. The tower stood until 1907. (Courtesy Thomas Jackson.)

Ravenswood, Queens, developed by Col. George Gibbs after 1814, boasted a private steamboat dock at the foot of Webster (now 37th) Avenue. A row of stunning early-Victorian mansions lined Vernon Boulevard, but the community was slowly strangled by industry after the Civil War. Today, this is part of the massive "Big Allis" power plant; only the stone retaining wall remains. (Courtesy Vincent Seyfried.)

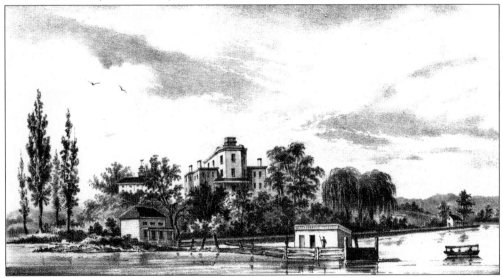

Just before the whirlpools and tides of the Hell Gate, at Lawrence Point, stood Casina, the farm of horse breeder George Woolsey. After 1890, the estate was broken up and the 1750 mansion torn down. The dock at the Hell Gate was a fine place for fishing. Today, this is the site of the massive Charles Poletti power plant. (Courtesy GAHS.)

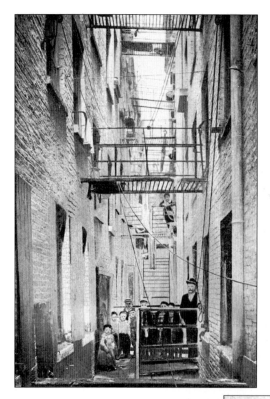

The most crowded place on earth, the Lower East Side was the setting for the notorious Five Points neighborhood. Buildings were constructed in backyards, many without windows and most without electricity, sewers, and running water. The sun shone here for only a short while each day, if at all. (Courtesy GAHS.)

Misery, violence, and disease stalked these hovels. Here, a backyard is strewn with waste, garbage, mud, and standing water behind a barracks. This was home to the "Gangs of New York," as the Bowery Boys, Dead Rabbits, and Plug Uglies infested the East River piers. The Reform Movement started by Jacob Riis and Theodore Roosevelt, among others, swept away these slums. (Courtesy GAHS.)

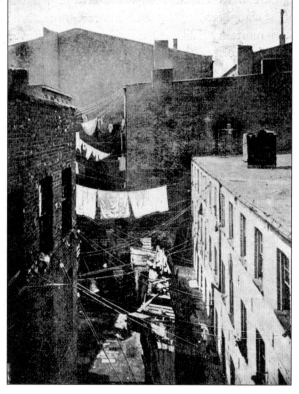

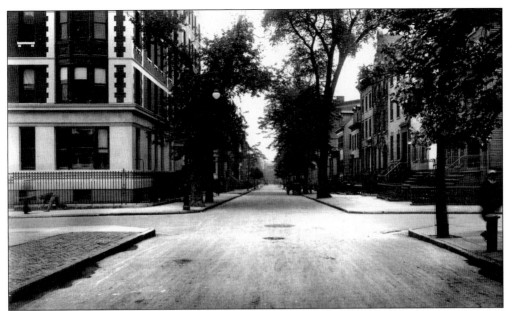

Just across the Brooklyn Bridge was another world from the Lower East Side tenements. The mansions and fine houses in Brooklyn Heights, here at the corner of Willow and Clark Streets in 1915, were home to wealthy merchants, businessmen, and bankers. (Courtesy Brian Merlis.)

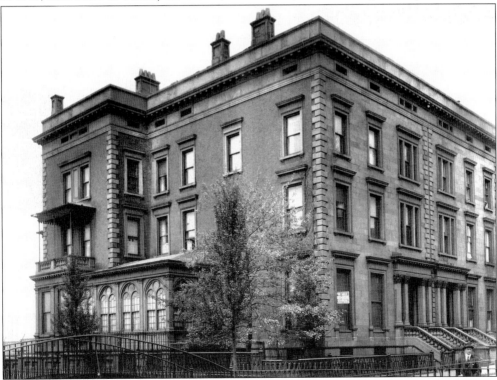

This mansion, built in 1856 on Pierrepont Place in Brooklyn Heights, was a single-family home within sight of the Lower East Side slums. Brooklyn was the first commuter suburb of New York. (Courtesy Brian Merlis.)

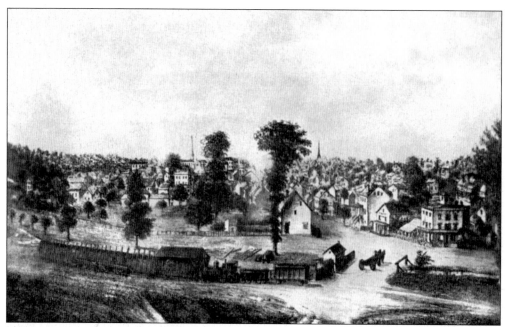

In 1790, Morrisania was proposed as the site of the federal capital. With the coming of the railroad, it became a village (1848), a town (1855), and finally a part of New York City (1874). Until the 1920s, it was the political center of the borough. This c. 1861 view shows 160th Street at Brook and Third Avenues. (Courtesy GAHS.)

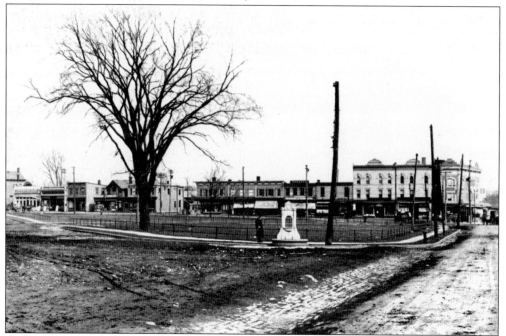

Westchester Square, established in 1654, was the first European village in the Bronx. As a port on Westchester Creek, most of its population was involved in the maritime trades on the East River. From the American Revolution of 1776 to the Draft Riots of 1863, history coursed through this square. (Courtesy Bronx County Historical Society Research Library.)

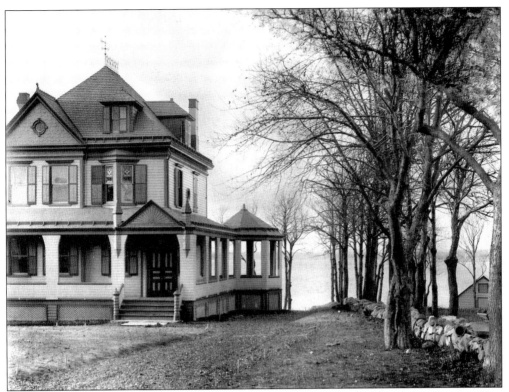

College Point photographer Jacob Weiners Jr. took this photograph of the Francis Clair mansion on Poppenhusen Avenue in 1895. Before selecting Gracie Mansion in Manhattan, the City of New York considered renting property nearby for the mayor's residence. (Courtesy Poppenhusen Institute.)

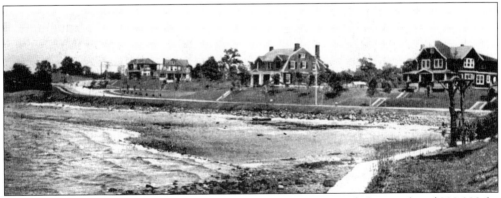

A group of some 200 New Haven bankers and Yale professors pooled more than $200,000 for the development of Malba, a name derived from the first letters of the surnames of the five leading investors. Originally a gated community, this section of the East River remains a wealthy, secluded enclave similar to developments farther out on Long Island's North Shore. (Courtesy GAHS.)

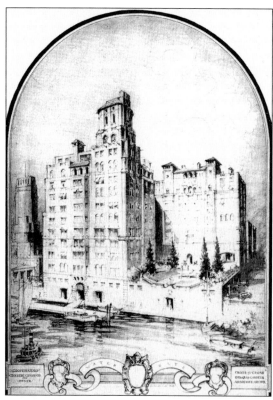

New riverfront luxury apartments like the Watergate, pictured here at 49th Street, sprang up on Beekman Place and Sutton Place in the 1920s and 1930s. The boat dock and great formal garden on the East River were gone within a few years, replaced by the FDR Drive. The dynamic contrast of new high-rise apartments next to old tenements provided the backdrop for the movie *Dead End*. (Courtesy Robert Singleton.)

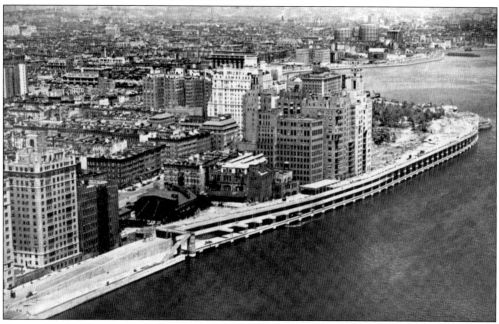

Taken shortly after the completion of the new East River Drive, this aerial view shows the double-deck highway and riverfront park from approximately 80th Street to beyond Gracie Point. The highway is now called the Franklin Delano Roosevelt (FDR) Drive. (Courtesy NYC Municipal Archives.)

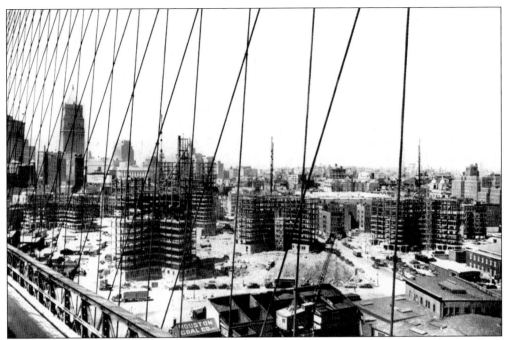

The Gov. Alfred E. Smith Houses, their namesake a local boy who rose to fame, are under construction in this late-1940s view. Some tenements on the East River were replaced by public housing projects. (Courtesy NYC Housing Authority.)

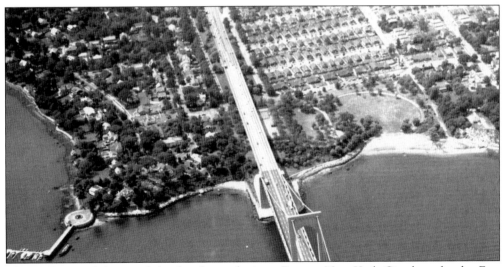

The 1898 consolidation of the five boroughs into Greater New York City brought the East River under one political jurisdiction, and everything on the river was fit under one master plan. Vacant land had disappeared by the mid-20th century. Pictured here is new housing in the Bronx c. 1955. (Courtesy Daniel Zirinsky.)

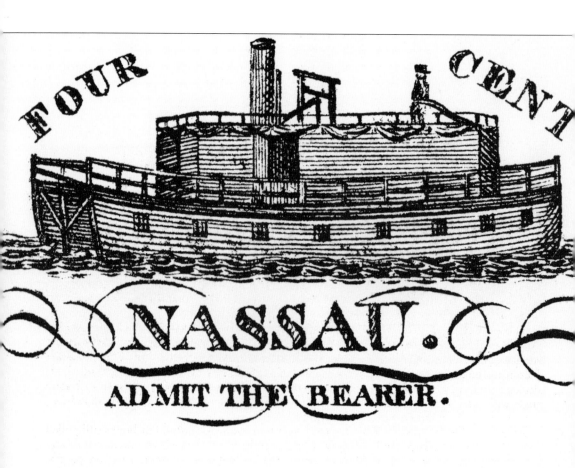

FOUR CENT

NASSAU.

ADMIT THE BEARER.

For 4¢, one could ride on the *Nassau*, an early Brooklyn ferry. A range of fees applied to wagons, pedestrians, and livestock. Although ferries existed in colonial times (boats were summoned by blowing a horn or ringing a bell), their service was infrequent. Only with the advent of the steam engine after 1812 could regularly scheduled service begin. (Courtesy GAHS.)

Four
TRANSPORTATION

As much as the East River is shared by four of New York City's most populous boroughs, it also divides them. Manhattan residents have long used the phrase "bridge and tunnel crowd" as a shorthand jab at people living in the outer boroughs. But that island's business districts and cultural centers would wither away without the creativity and labor of commuters. For this reason, successive city governments and private entrepreneurs have spent billions of dollars— and tragically, sometimes workers' lives—weaving together this conurbation with numerous bridges, tunnels, ferries, and even a tram.

Though Europeans first arrived by sail, settlers rowed along the East River much as Native Americans paddled dugout canoes before them. Robert Fulton's steamboats provided the first service in which passengers could adhere to a set schedule. Although New York State rewarded Fulton's company with a monopoly on steamboat service in New York, the Supreme Court decided in its 1824 Gibbons v. Ogden decision that this sweetheart deal restricted interstate trade with New Jersey, which shares the harbor. With the door thrown open to competition, the waterways soon buzzed with constant traffic.

After the Civil War, New York City life began to move much faster. But horses still pulled carriages away from ferry landings right into the 20th century. Much as raw materials and industrial goods were handed off between water craft and rail cars and trolleys, so were people. Terminals for the revived ferry industry of the late 20th and early 21st centuries were also pegged to subway stations and the Long Island Rail Road.

Some of the bridges are masterful weldings of art and engineering and, as such, are deservedly landmarks in themselves. The creation of the granite-faced Brooklyn Bridge was dramatic, but accidents claimed more than 20 workers' lives, including designer John Roebling. Roebling's son Washington succeeded him but was paralyzed by a mishap in an airtight underwater caisson. He was able to complete his work from his home in Brooklyn only because his extraordinary wife, Emily, supervised the project on his behalf each day.

The longest suspension bridge in the world when it was constructed, the Brooklyn Bridge allowed people and goods to flow between Manhattan and Long Island regardless of weather. In the century following its construction, the population of Brooklyn soared from just half that of Manhattan to the largest in New York City. The Queensboro Bridge is a cat's cradle of interlaced steel, bringing a surprising mix of weight and grace to a rigid structure. Three bridges in one, the Triborough Bridge remains one of the most complex transportation structures attempted.

The celebrated bridges and unsung tunnels that span and pass under the East River logically and psychologically stitch the city together. As Manhattan real estate prices soar, East River neighborhoods in Queens and Brooklyn have become extensions of the midtown office district and the funkier East Village.

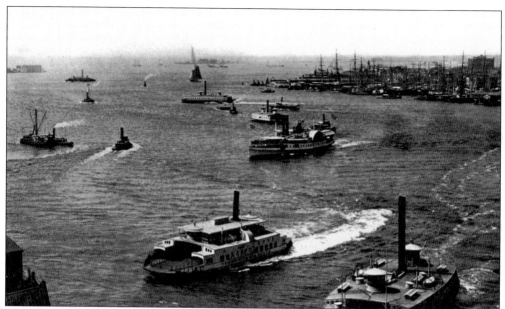

This dizzying array of ferries, barges, tugboats, paddle steamers, and smaller vessels resembles a modern traffic jam between Brooklyn and Manhattan in the last quarter of the 19th century. In the distance is the Statue of Liberty. Before the tunnels and bridges of our transportation network carried traffic under and over the river, a virtual gridlock of vessels jostled their way across. (Courtesy GAHS.)

These gantries, or float bridges, at the Hunters Point terminal on the East River helped guide and lift railroad cars. Filled with materials such as coal or gravel, the barges were then floated to Manhattan or New Jersey to link up with the continental rail network. The gantries have been preserved, as shown on page 126. (Courtesy GAHS.)

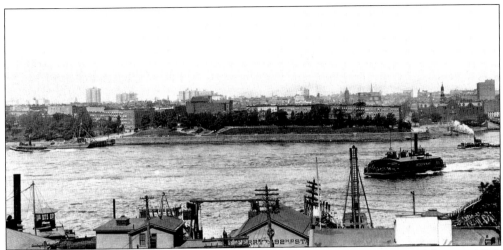

Stephen Halsey, the "Father of Astoria," obtained the charter for Old Astoria Village in 1839. At the same time, he purchased steamboats and started a ferry service to Manhattan. Between 1843 and 1918, the New York and East River Ferry Company made regular trips first to 86th Street, then after 1894, to 92nd Street. Shown in the background are Gracie Mansion and an early Carl Schurz Park. (Courtesy Bob Stonehill.)

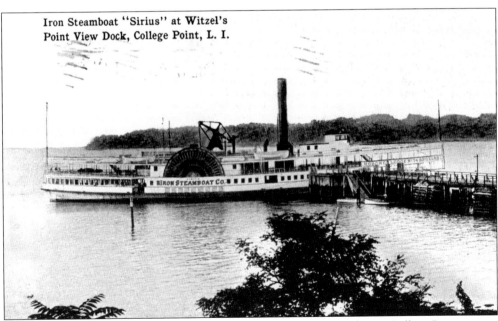

The iron steamboat *Sirius*, docked at Witzel's Point View Beer Garden in College Point, awaits the afternoon crowd for the return trip. These steamers were standard fare for summer excursions until a series of disasters revealed paddle wheelers unseaworthy and their wooden timbers a tinderbox. (Courtesy Poppenhusen Institute.)

At the date of this photograph (*c.* 1875), more than 20 different ferries carried over 50 million passengers a year. The Brooklyn Bridge (seen here under construction) symbolized the beginning of the end for the Brooklyn ferries. With the opening of the Queensboro, Triborough, and Whitestone Bridges over the next 60 years, a similar fate awaited the ferries on the upper river. (Courtesy Robert Singleton.)

At the foot of Fulton Street, Brooklyn, the Fulton ferry terminus (1871–1925) bustles with activity in 1873 as horsecars prepare to climb the hill into the country's fourth-largest city. In the background, the Brooklyn Bridge is being built. (Courtesy Brian Merlis.)

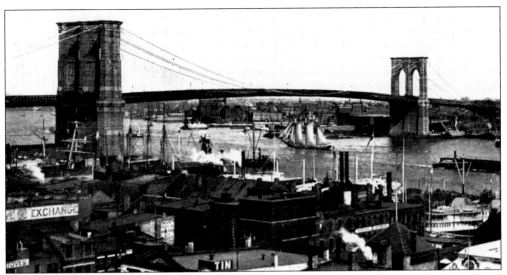

Perhaps no bridge has captured the public's imagination like the Brooklyn Bridge, completed in 1883. Its deck was fixed at 133 feet, for years the maximum height for U.S. Navy vessels that had to pass under it en route to the Brooklyn Navy Yard. Newer vessels that exceeded the limit had to be completed after passing under the bridge. (Courtesy GAHS.)

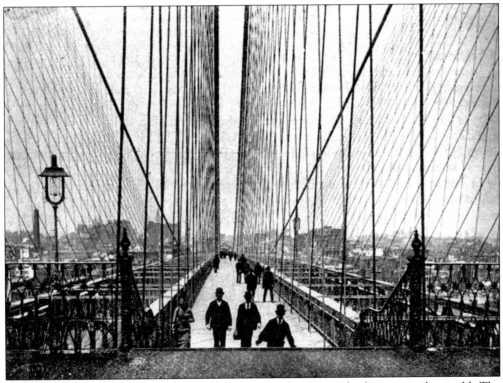

The span between towers, at nearly 1,600 feet, was for a time the longest in the world. The roadway was suspended from steel cables, while vertical wires reinforced with diagonal stays connected the roadway to the cables. This view from the pedestrian walkway on the Brooklyn Bridge is a triumph of function and beauty. (Courtesy GAHS.)

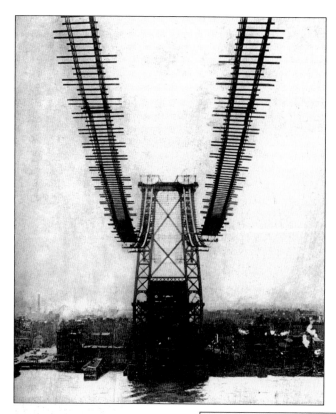

The Williamsburg Bridge opened in 1903. The great exodus from the squalid Lower East Side slums found this a passageway to a better life. Its span is 5 feet longer than the Brooklyn Bridge and, at 7,300 feet, is the longest of the Lower East Side bridges. Unique to New York spans, it was designed with a bicycle path. (Courtesy GAHS.)

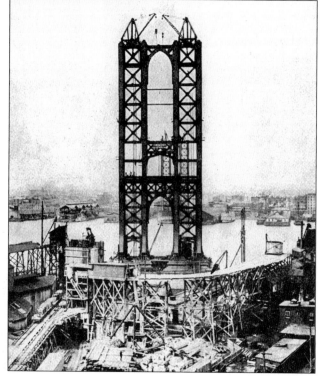

The 1909 Manhattan Bridge was the last link between Brooklyn and Manhattan. A grand arch and colonnades on Canal Street belie a troubled span burdened with deferred maintenance, as well as structural and building flaws. The bridge was a workhorse, with seven vehicular lanes, four subway tracks, and a pedestrian walkway. It took decades of repairs to remedy its problems. (Courtesy GAHS.)

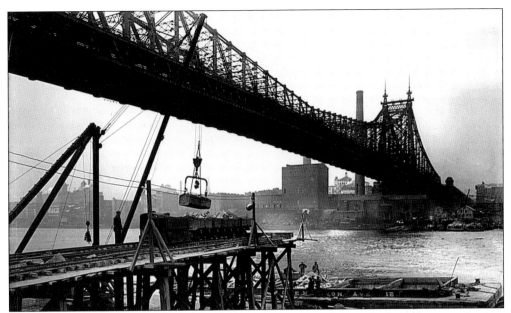

The Queensboro Bridge, completed in 1909, is the longest of the eight bridges across the East River, at 7,450 feet. In the planning stages since the Civil War, the promise of its construction was one of the incentives to bring Queens into New York City. Often called the 59th Street Bridge, this two-level cantilevered masterpiece was built by Gustav Lindenthal. It is a New York City landmark. (Courtesy GAHS.)

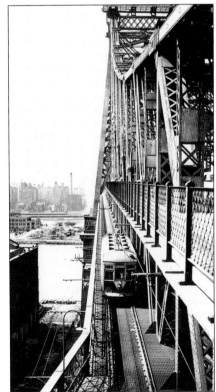

In 1957, the last trolley in New York was the Queensboro Bridge line, whose final days were popular with nostalgia buffs who wanted a taste of a slower, dreamy pace from a bygone era. The bridge continues as a backdrop to inspire poets (Paul Simon: "Feelin' Groovy") and artists (Woody Allen: *Manhattan*). (Courtesy Vincent Seyfried.)

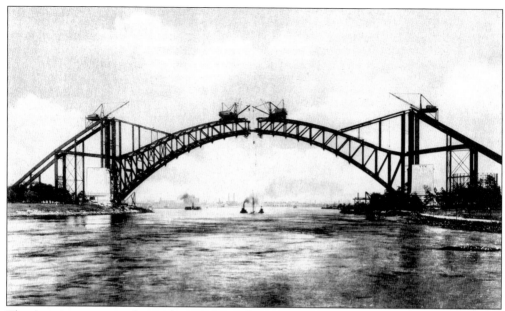

The Astoria community has embraced the Hell Gate Bridge as its own. In this September 1915 photograph, it is under construction. When the arch sections met, they were out of alignment by only five-sixteenths of an inch. The Hell Gate Bridge is the world's longest four-track rail bridge. Engineers boast that with regular coats of paint, it can last as long as the pyramids. (Courtesy Robert Singleton.)

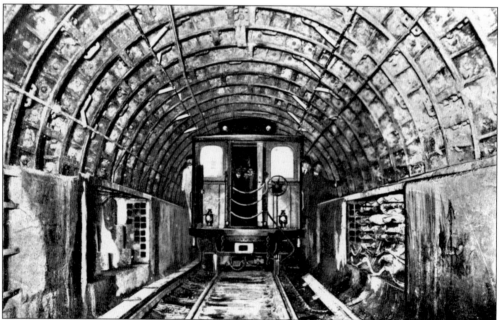

The subway reached Brooklyn on January 9, 1908, winning a race with the PATH tubes to New Jersey by one month. Although the cast-iron rings look solid here, a worker was actually sucked through the roof during a "blow-out" in 1905. Miraculously, he survived being pulled through the riverbed and shot to the surface, where the astonished crew of a tug picked him up. (Courtesy GAHS.)

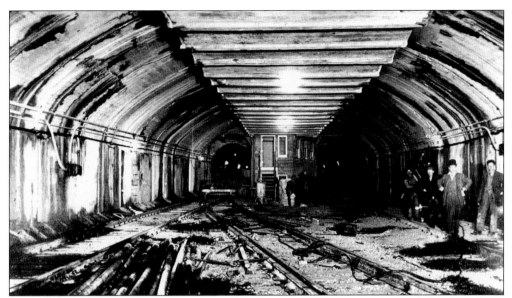

The remarkable William Steinway, manufacturer of pianos and creator of the Steinway settlement on the waterfront, was deeply committed to transportation. He designed the New York City subway network and suggested the rail tunnel from New Jersey to Long Island decades before the Pennsylvania Railroad. The Steinway Tubes, pictured here, opened in 1915, nearly 20 years after their construction was halted by his untimely death. (Courtesy Vincent Seyfried.)

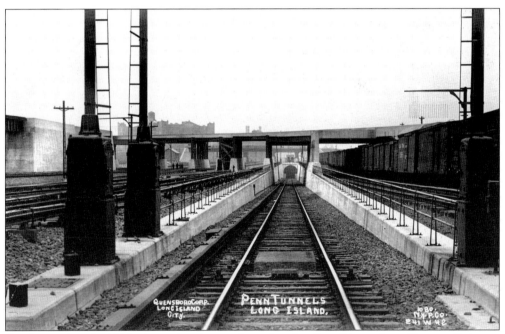

On September 8, 1910, the railroad tunnels under the East River, from Hunters Point to midtown Manhattan, opened. Pictured here is one of the tunnel entrances in Queens. Newly electrified trains from Long Island or New England would soon run under the East River into Pennsylvania Station. Nearly 100 years later, a second rail tunnel under the river readies service to Grand Central Station. (Courtesy Bob Stonehill.)

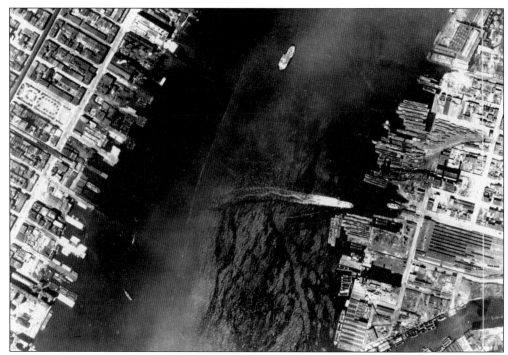

In this aerial view, a ferry arrives at the Hunters Point terminal from 34th Street in Manhattan. Just east of the ferry docks are the Long Island Rail Road yards. Long Island passenger service and trolley lines from Queens converged at the ferry. Freight trains were loaded onto rail barges for river travel to New Jersey rail terminals and the continental United States. The ferry was discontinued in 1925. (Courtesy GAHS.)

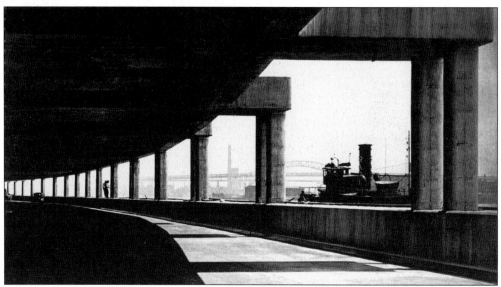

With the Triborough and Hell Gate Bridges in the distance and a tugboat to the right, the East River (now FDR) Drive weaves its way north. Above are Carl Schurz Park and the mayor's residence at Gracie Mansion. Portions of the drive were constructed on rubble brought over as ballast from the World War II blitz on London. (Courtesy NYC Municipal Archives.)

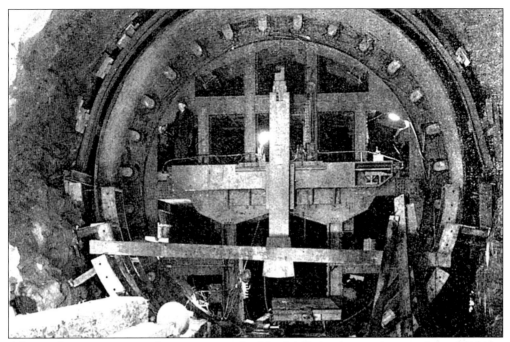

Advanced construction techniques, as with this shield in the south tunnel, enabled the Queens-Midtown Tunnel to be completed in only four years, from 1936 to 1940. Tunneling a 31-foot bore occurred 24 hours a day, six days a week from Manhattan to Queens. Downriver, the Brooklyn Battery Tunnel, which opened in 1950, is the longest underwater tunnel in the nation. (Courtesy MTA Bridges and Tunnels Special Archive.)

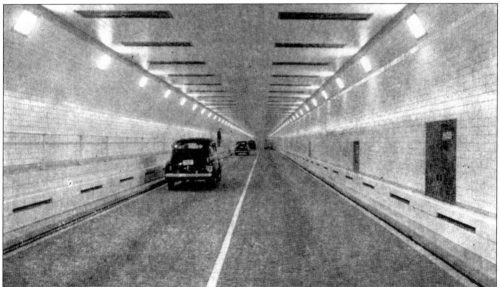

The $58 million Queens-Midtown Tunnel opened to vehicular traffic in 1940. It included remote controls for ventilation and lighting, offices, quarters for maintenance crew and police, garages, and booths for collecting tolls on the Queens side. Along with the Lincoln Tunnel, it linked midtown Manhattan with the fast growing suburbs. (Courtesy MTA Bridges and Tunnels Special Archive.)

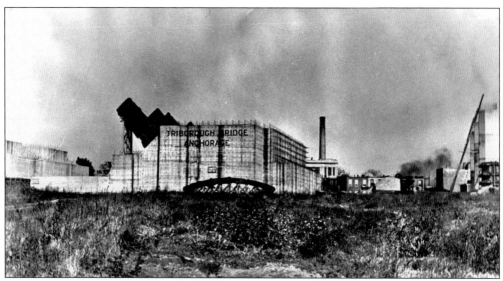

In the early 1930s, the Triborough Bridge was born in Astoria Park, where embedded steel eyes in the cable anchorage and concrete pillars for the roadway peeked above ground. Spanning the waters between Manhattan, the Bronx, and Queens, three bridges create one of the most complex interchanges ever built. Financing this behemoth spawned the creation of the Triborough Bridge and Tunnel Authority. (Courtesy GAHS.)

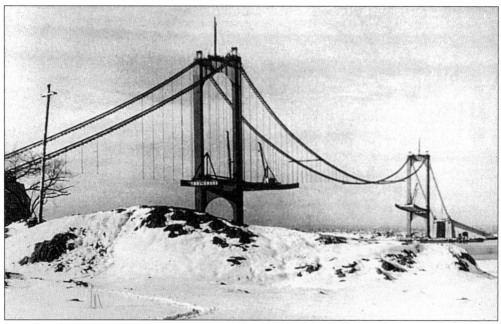

Completed in only 23 months at a cost of $17 million, the Bronx-Whitestone Bridge was opened in 1939 as part of the transportation network for the Flushing Meadows World's Fair. This graceful collaboration between Othmar Ammann and the firm of Cass Gilbert spurred a housing boom in both the Bronx and Queens. (Courtesy Queens Borough Public Library.)

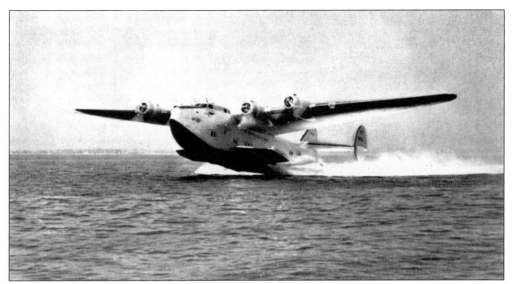

A Pan American Airways transatlantic clipper takes off from Bowery Bay on the East River at LaGuardia Airport c. 1940. The *Yankee Clippers* plied the Atlantic Ocean via the Azores and Lisbon. Carrying less than a dozen passengers and 5,000 pounds of freight, these powerful four-engine flying boats were in service for only a few years before World War II. (Courtesy GAHS.)

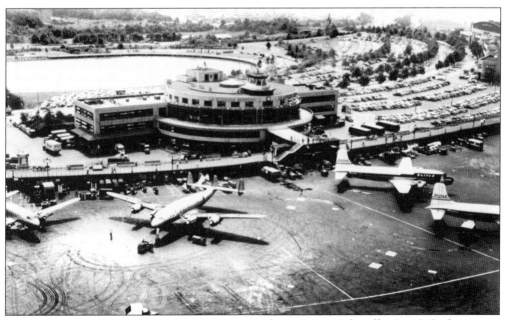

On December 2, 1939, LaGuardia Airport opened to commercial traffic. In 1947, the airport was leased to the Port Authority. A new central terminal building was opened in 1964, enlarged in 1967, and again in 1992. LaGuardia Airport in a recent year handled 21 million people, 360,000 flights, and more than 34,000 tons of freight and airmail. The airport is pictured here in 1950. (Courtesy GAHS.)

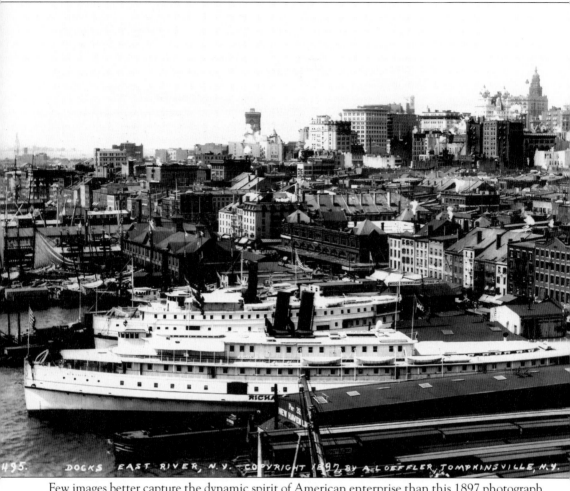

Few images better capture the dynamic spirit of American enterprise than this 1897 photograph of lower Manhattan. Banks on Wall Street, corporate headquarters on Broadway, and counting houses on South Street all trace their heritage back to the docks of the East River. Steamboats, barges, and ships of sail all draw in the strands of local and international commerce. (Courtesy Robert Singleton.)

Five

FROM AGRICULTURE
TO INDUSTRY

The lands cupping New York Harbor were formed perfectly for both commerce and farming. The two lifestyles coexisted for centuries on the East River. Farming near the waterway persisted in the outer boroughs right up into the 20th century, though, of course, trade and industry came to both define and defile the East River.

Once again, names remind us of an invisible past. The footstool of the East River, Governors Island, was known as Nut Island to the Dutch for the hickory trees that made it an ample provider of food. Bowery Bay takes its name from the Dutch word for farm, *bouwerie*. Crops grown for charity there fed New York's hungry widows and orphans. American horticulture was pioneered in Flushing. Grant Thorburn, in Astoria, became that community's first postmaster when his seed business overwhelmed the township's post office. Although farming along the East River has disappeared, the Hunts Point Cooperative Market is the world's largest wholesale distribution center.

Wall Street profited from the East River's central role in trade, especially for cash crops like coffee, cotton, and tea. Sadly, people were bought and sold alongside goods, to the great profit of New York City merchants. There was a time when to step ashore at Wall Street was to literally enter a slave market—ancestors of today's African Americans were chained and bid upon right there.

In the 19th century, the federal government was greatly dependent on tariffs collected in New York City. In the industrial boom following the Civil War, however, energy became the biggest moneymaker on the East River. New York Harbor is a key port for the oil industry, providing a conduit for heating oil destined for northeastern homes, and other fuel grades for cars, trucks, trains, ships, and power plants.

Imported agricultural products like sugar, cotton, rubber, and tobacco were treated and refined on the banks of the East River. The transformation from raw commodity to consumer good often took place just yards from the piers. The hum of activity reached a fever pitch in the middle of the 20th century, with local businesses exporting products as diverse as Steinway pianos and Sikorsky aircraft.

Such intense industrialization has been tremendously beneficial to the national economy and local living standards, but has come at a price to the river itself. Spills and leaks from petroleum, varnish, paint, and related chemical plants were so common that some East River inlets and creeks actually had flammable surfaces. The water and soil below was dead too, saturated with toxins used by those industries, metallurgy, and leather tanning.

In addition, electrical generators that rely on cooling water and turbine steam dot the shoreline. Echoing the path of planned future development, these plants are expanding their presence in Queens while being sold off in Manhattan. The East River's generating capacity provides for three-quarters of New York City's electricity needs.

Bowery Bay, Queens, is pictured here in 1869. The harvest from the Poor Farm (*Bouwerie*) sustained widows and orphans of *Nieuw Amsterdam*. Within just a few miles of the bustle of the lower East River, this tranquil scene captured some of the best agricultural land in the state. The rich earth of fertile Long Island provided for the tables of Manhattan. (Courtesy Andrew Motta.)

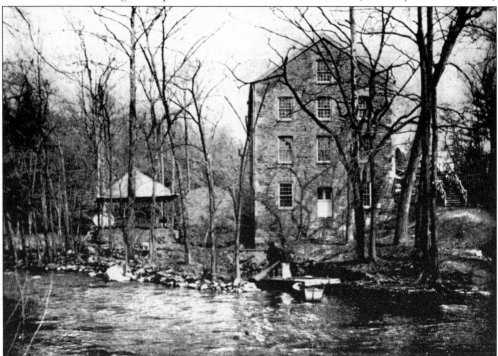

The Old Lorillard Snuff Mill stands on the east bank of a narrow gorge of the Bronx River in Bronx Park. Between 1840 and 1845, the snuff mill and dam were built on the river. Pierre Lorillard, a tobacco company owner, and his family lived in a mansion overlooking the location. This New York City landmark is one of the oldest buildings in the Bronx. (Courtesy GAHS.)

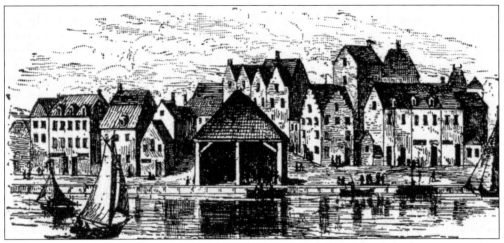

The slave market at Wall Street reminds us that New York was one of the last states to ban slavery before the Civil War. African Americans made up a significant minority in the communities along the East River, particularly in Brooklyn and Flushing. As warehousemen, shipwrights, smiths, coopers, carpenters, and sailors, a large community of skilled freemen contributed to every facet of commercial life along the river. (Courtesy GAHS.)

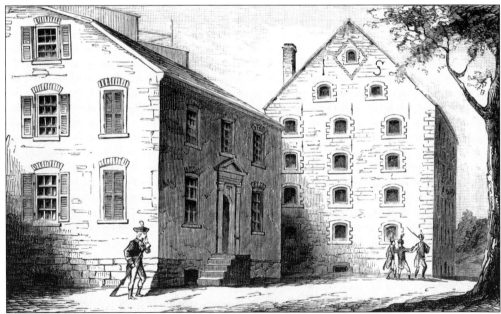

The crown jewels of colonial empires were the sugar islands. New York, part of the triangular trade between the Caribbean and England, became a center for milling and refining sugar cane. This sugar warehouse on Liberty Street was used as a prison during the Revolutionary War and stood until the 1890s. Sugar refining on the East River ended when the Domino Sugar plant closed in January 2004. (Courtesy GAHS.)

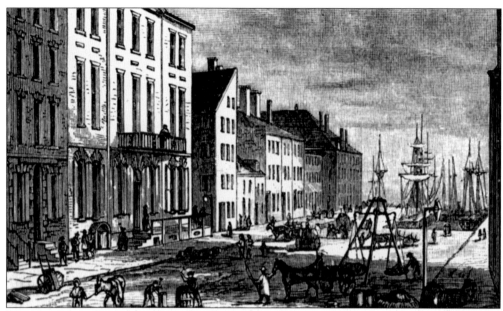

The Tontine Coffee House, shown here, opened in the 1790s at the corner of Wall and Water Streets. Legend claims that at a nearby Buttonwood tree, stockbrokers and merchants established the New York Stock Exchange in 1792. These informal meetings grew to become the epicenter of world financial activity. Thus, Wall Street was born at the waterfront. (Courtesy GAHS.)

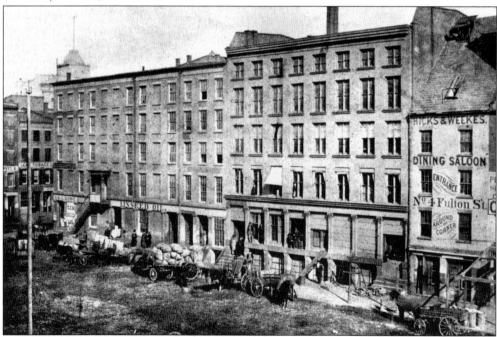

Some of the most valuable real estate in the nation lay under these warehouses on John Street, at Burling Slip, c. 1865. A continuous stream of goods from around the nation and the world flowed in and out of these buildings. Goods were stored in the upper stories, and the counting house was on the first floor. (Courtesy South Street Seaport.)

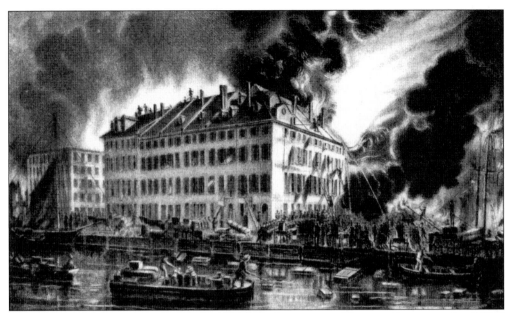

The "Great Conflagration of December 1835" broke out near Hanover Street, south of Wall Street, and destroyed the last remnants of 17th-century Dutch New York. The destruction of the financial center and waterfront on the East River overwhelmed both the banking and insurance industries. The resulting Panic of 1837 was exceeded in severity only by the Great Depression of the 1930s. (Courtesy GAHS.)

In the post–Civil War era, the country entered a period of explosive economic growth. Some of the earliest oil refineries of the Rockefeller empire were built on Newtown Creek. A series of spectacular fires at the paint and varnish businesses, refineries, and chemical works prompted calls by reformers to clean up the polluted East River and its tributaries. Newtown Creek still bears brownfields from this era. (Courtesy Robert Singleton.)

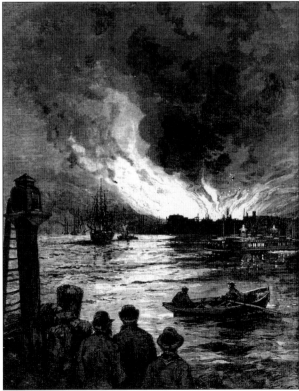

In the 1840s, German immigrants began to settle in a number of communities along the river, such as Klein Deutschland in the Lower East Side, Yorkville, Morrisania, and College Point. Several breweries opened near the river, and beer baron George Ehret was co-owner of North Beach Park on the East River. In College Point, beer gardens and seaside recreation venues remained popular until Prohibition. (Courtesy Poppenhusen Institute.)

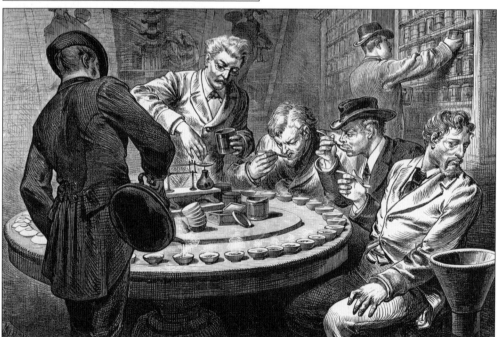

Here, a Front Street warehouse tests and grades coffee in 1876. From the early 19th century, a regular supply of exotic goods and produce from around the world was available in New York. The trading of goods and commodities on the Cotton Exchange or Produce Exchange was as important as the buying and selling of stocks and bonds on Wall Street. (Courtesy GAHS.)

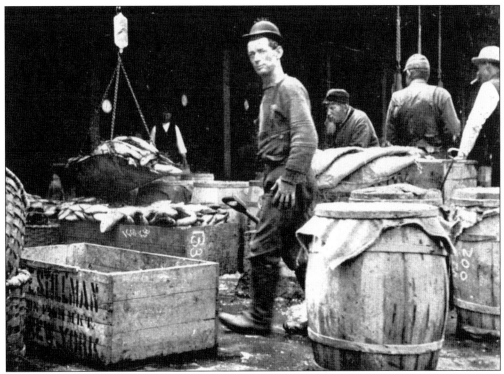

The fishing fleet that plied the Atlantic Ocean and nearby waters brought its daily catches to the Fulton Fish Market. Begun in the 1830s, it was one of the largest fish markets in the world. Plans are under way for the fish market to move to Hunts Point in the Bronx. (Courtesy Robert Singleton.)

Markets on the East River were convenient to both farmer and consumer. The Queensboro Bridge was designed with a market in its Manhattan base, and the Williamsburg Bridge supported the Woodbury Free Fruit and Vegetable Market. From old Brooklyn's Wallabout Market to today's Hunts Point Cooperative Market in the Bronx, the river retains its importance as a setting for commerce. (Courtesy GAHS.)

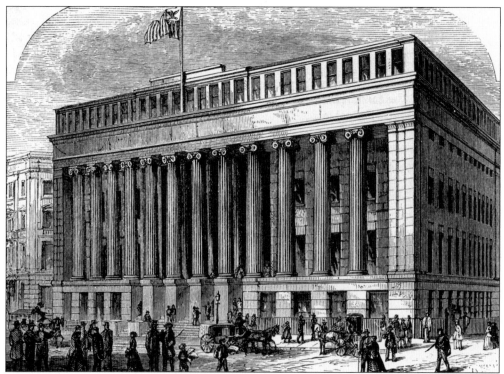

Before personal income taxes, the largest source of revenue for the federal government was customs duties. The customs house of New York port, which had the bulk of the nation's trade, was by far the most important. This building, at 55 Wall Street, was constructed *c.* 1840 and served as customs house from 1862 to 1907. Until recently, it was the corporate headquarters for Citibank. (Courtesy GAHS.)

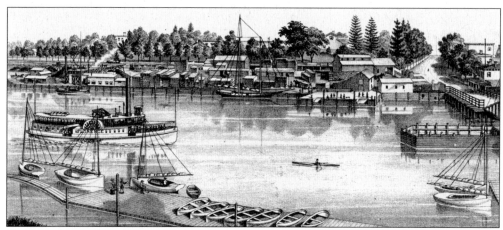

Commercial centers on the upper East River, such as Port Morris and Unionport in the Bronx and Flushing in Queens, made important contributions to the river. The Flushing waterfront (seen here around the 1870s) was an important link in a web of commerce with Long Island's North Shore and the New England coast, dating back to early colonial times. It was also the birthplace of the American horticultural industry. (Courtesy Robert Singleton.)

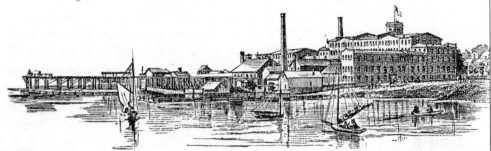

The India Rubber Comb Company was the cornerstone of Conrad Poppenhusen's College Point industrial empire. With foresight, this entrepreneur and philanthropist invested in the community's transportation and housing and was a major stockholder in the Long Island Rail Road. He started the Poppenhusen Institute, a vocational school, in 1868 and founded the first kindergarten in the country. (Courtesy Poppenhusen Institute.)

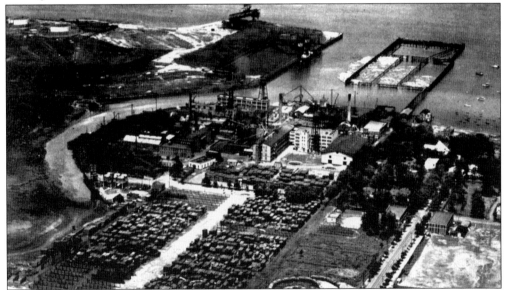

This 1925 view of the Steinway Piano factory shows the pens for log rafts that floated timber down from Maine. To the factory's back door, freighters brought in rare woods from around the world for veneer. From his mansion overlooking Bowery Bay, William Steinway, as New York's first subway commissioner, conceived the city's subway network and started the largest circulating library in the country. (Courtesy Queens Chamber of Commerce.)

71

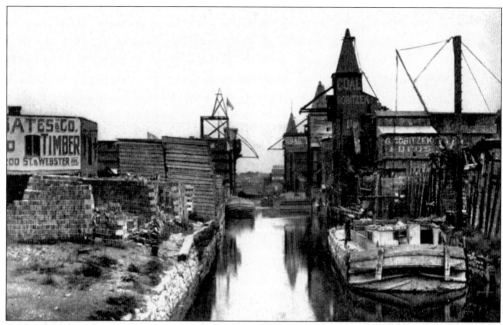

The Mott Haven Canal, although just off the East River in the Bronx, was an important destination for barge traffic. For bulk cargo, water travel was the cheapest form of transportation. Other important canals on the river included Anable Basin (Hunters Point) and Whale Creek (Greenpoint). (Courtesy GAHS.)

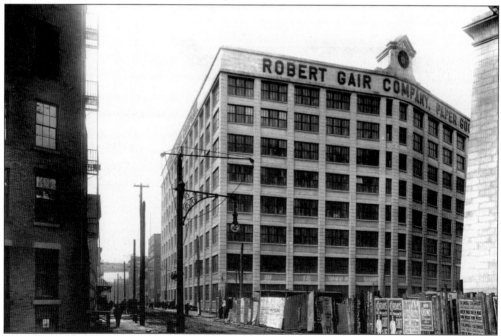

The Brooklyn waterfront, from Red Hook to Newtown Creek, possessed seven miles of industry ranging from shippers, warehouses, and ferry terminals to breweries, slaughterhouses, granaries, shipyards, ironworks, and factories. Pictured here in 1909 is the Robert Gair Company Paper Goods building on Front Street. (Courtesy Brian Merlis.)

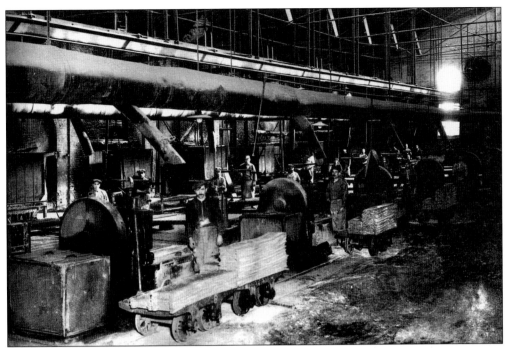

Workers at the Laurel Hill Chemical Works on Newtown Creek, seen *c.* 1905, labor in one of the most polluted locations in the region. At the end of the 19th century, the four-mile creek was said to have a greater concentration of industry and more traffic than the Mississippi River. (Courtesy GAHS.)

Dutch Kills, so named for a series of Dutch settlements in the 1640s, is a branch of Newtown Creek. Degnon terminal, seen in the background, was built in 1905 as a state-of-the-art intermodal rail and industrial facility. It was housed in fireproof, well-ventilated buildings, quite a contrast to the working conditions shown above. Until recently, the Sunshine Biscuit Company building was the International Design Center. (Courtesy Vincent Seyfried.)

This image of Furman Street in Brooklyn, on a foggy morning in 1914, captures an important reason that the East River was attractive to businesses. Shipping centers, rail facilities, and bridge traffic converge on the waterfront with ample warehousing and storage. (Courtesy Brian Merlis.)

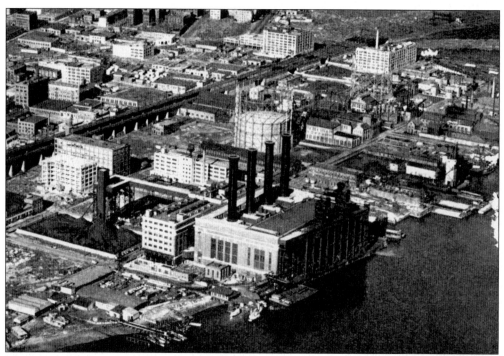

This power plant at Port Morris in the Bronx provides energy that is reliable, plentiful, and cheap. The East River is the center for power generation in the New York area. Major plants are at 14th Street in Manhattan, Hudson Avenue in Brooklyn, and the Poletti facility in Queens. "Big Allis" in Ravenswood, Queens, serves more than two million customers and is one of the world's largest electricity generators. (Courtesy GAHS.)

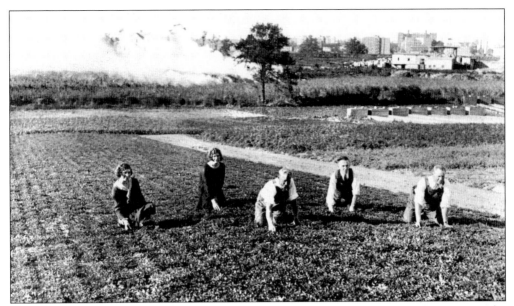

The Fuellner family maintained a thriving farm near Soundview and Lafayette Avenues in the Bronx in the 1920s. It was amazing that even at this late date, portions of the East River in the Bronx and Queens remained essentially unchanged from colonial times. (Courtesy Bronx County Historical Society Research Library.)

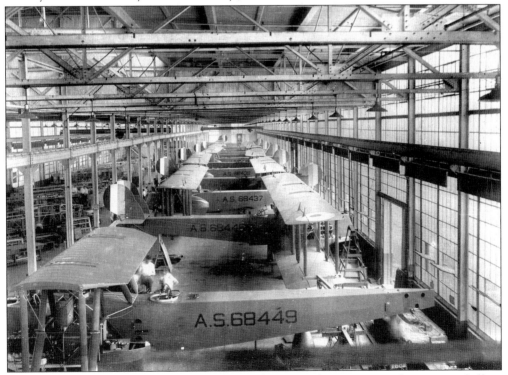

About the same time as the Fuellners were picking strawberries, across the river in College Point, airplanes were being mass-produced at the plants of Sikorsky Aircraft, the LWF Company (pictured), and Edo. (Courtesy Poppenhusen Institute.)

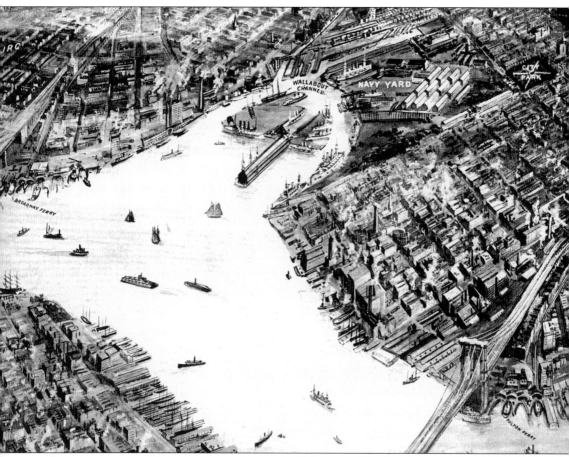

Few places are as rich in history as the nearly 300 acres of land and water that made up the Brooklyn Navy Yard. Here were forged the tools that made the U.S. Navy the most powerful one on earth. This is an aerial perspective created prior to the 1909 completion of the Manhattan Bridge. (Courtesy GAHS.)

Six

SHIPPING AND SHIPBUILDING

Before New York City built soaring towers and heroic bridges, it built magnificent ships. This critical industry got off to an accidental start. The Dutch sloop *Tyger* was destroyed by fire off the coast of Manhattan in 1613; its crew, with the help of the local Lenape people, then built a 42-foot-long replacement ship over the winter. The *Onrust*, or "Restless," was one of the first seafaring vessels to be built in the colonies, and the first European craft to explore the full length of the East River.

Shipbuilding continued on the East River, but often the most significant vessels were those that cruised into the harbor from Europe—as likely to recruit pirates or smuggle contraband as to engage in legitimate trade. Many old money fortunes were made in the so-called Red Sea Trade of piracy and contraband.

The city's great catalyst for growth came from, of all things, legislation regarding grain. The Bolting Act of 1678 granted the colony of New York a monopoly on producing flour and shipping throughout the British Empire. Such a valuable and renewable export, grain legitimized the shipbuilding enterprise, spurring new industry and population growth. The city became the third leg of the triangular trade between London and the Caribbean.

The most powerful announcement to the world of American independence was not its Declaration, but its flag flying high on merchant ships bound for every port. Just three years after the British relinquished their claim on the former colonies, the *Experiment* sailed from the East River to China.

The river became a magnet for shipbuilders, captains, and counting-house merchants whose enterprises built a nation. By the middle of the 19th century, New York had become what Walt Whitman would call the "city of spires and masts." Packet ships, following a regular departure and arrival schedule, and clipper ships, the ultimate mix of wood, canvas, and sleek design, were that century's signature stamp on the East River.

The naval ships built on the East River have an enviable history in naval warfare. The first submarine built, the *Turtle*, attacked a British warship during the Revolutionary War. The *Monitor*, the first full-iron vessel with a rotating turret (a "floating battery"), was assembled in Greenpoint, Brooklyn, during the Civil War.

The two other famous warships built in the Brooklyn Navy Yard entered the history books not as heroes in battle, but as victims to be avenged in war. The USS *Maine* exploded and sank under mysterious circumstances in the harbor of the Spanish colony of Cuba. That incident provided a catalyst for the Spanish-American War. The Japanese sneak attack at Pearl Harbor destroyed the East River–built USS *Arizona* and drew the country into World War II. That great war ended almost four years later aboard another Brooklyn Navy Yard ship, the USS *Missouri*.

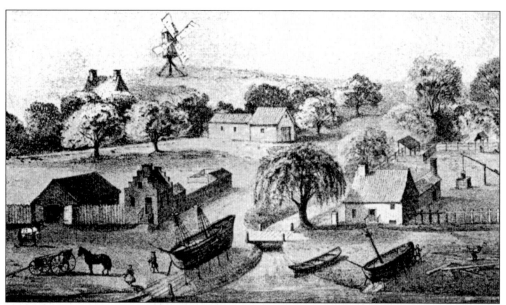

One of the earliest images of shipbuilding in New York shows vessels drawn up on dry dock, at T. Smit's Vly (Cove) at the foot of Maiden Lane, Manhattan. On the East River in 1631, the Dutch assembled the largest ship that would be built in this country for 150 years. It was a huge, 600-ton merchant vessel named *Nieuw Nederland*. (Courtesy GAHS.)

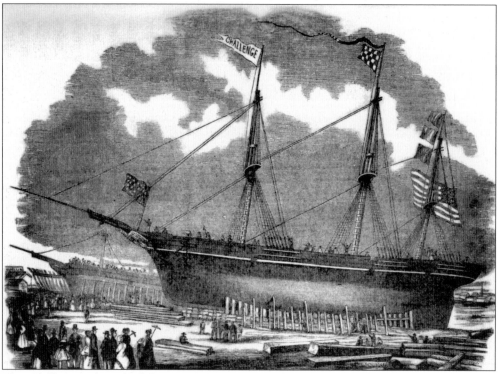

The *Challenge* is launched from a shipyard on the lower east side of Manhattan in 1851. Between the War of 1812 and the Civil War, more than 30 shipbuilders operated yards along the East River, from the Battery to 14th Street. (Courtesy GAHS.)

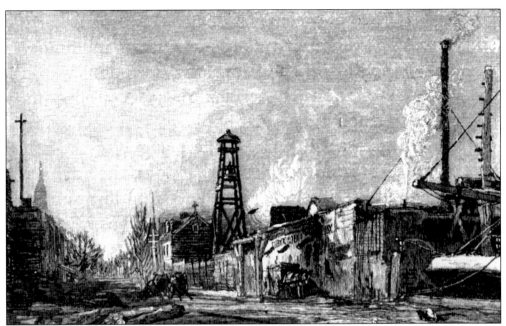

Shipwrights worked grueling hours in all types of conditions. The shipyards along the East River played an important role in the development of the early labor movement, when a strike wrung a pay increase and a shorter workday. The mechanics' bell tolled the start of the day, the lunch break, and the end of the workday. (Courtesy GAHS.)

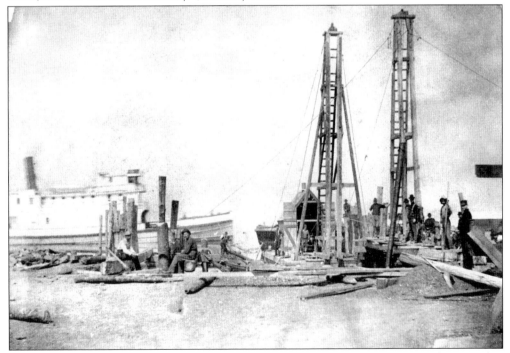

The waterfront itself was a large employer of dredgers, river pilots, carpenters, and many other maritime-related trades, as seen in this 19th-century photograph of Tyler & Mara, dock builders of College Point. (Courtesy Poppenhusen Institute.)

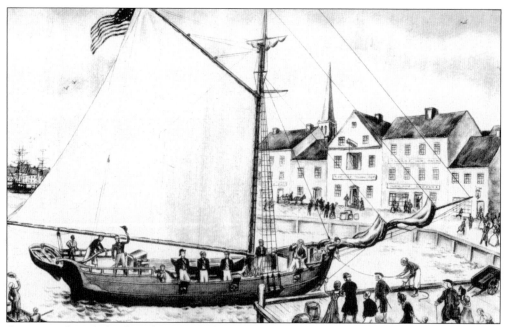

As soon as the ink dried on the Treaty of Paris in 1783, England lifted its blockade of New York, and the harbors of the world opened to the intrepid mariners from the young republic. The *Experiment*, pictured here leaving from the East River in 1786, was one of the first American vessels to make the round-trip to China. (Courtesy GAHS.)

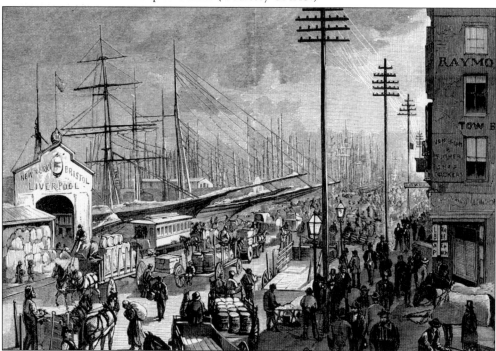

Streets along the East River were choked with commercial activity. Mighty ships of every description and from every port came here to deal their wares. This wharf at Burling Slip advertises its routes from New York to Bristol and Liverpool, England. (Courtesy GAHS.)

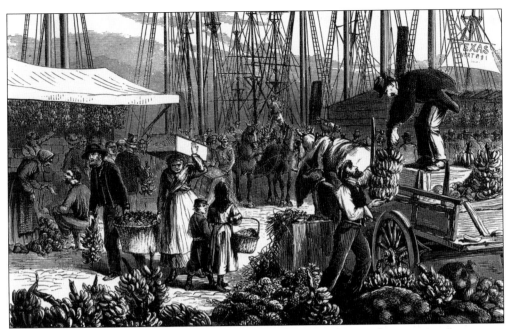

The dictionary defines "stevedore" as derived from the Spanish *estivador*, meaning "to stow or cram or to stuff objects." Stevedores, whose occupation was to stow goods in a ship's hold, loaded and unloaded vessels in New York port. They were skilled in handling everything from heavy bulk goods to delicate tropical fruits. (Courtesy GAHS.)

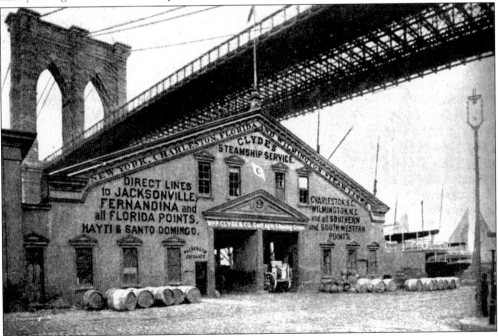

Not only did the Clyde Steamship Service ship to and from American ports like Charleston and Jacksonville, but also to foreign countries like "Hayti" and the Dominican Republic. New York City was the world's portal to the North American continent, whose highways are here symbolized by the Brooklyn Bridge. (Courtesy GAHS.)

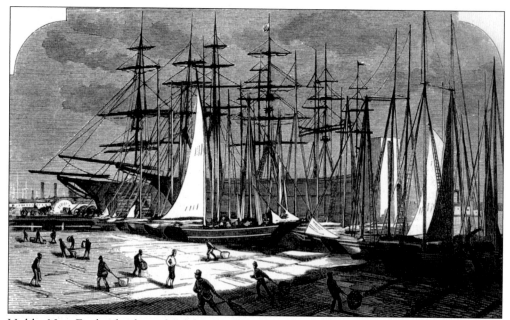

Unlike New England, where the fishing industry was a mainstay, New York was a destination for fleets from deepwater fishing. Locally, before pollution made New York Harbor unhealthy, the size of the clams, oysters, lobsters, and fish pulled from its waters were legendary. Here, a fishing fleet unloads its catch on the East River. (Courtesy GAHS.)

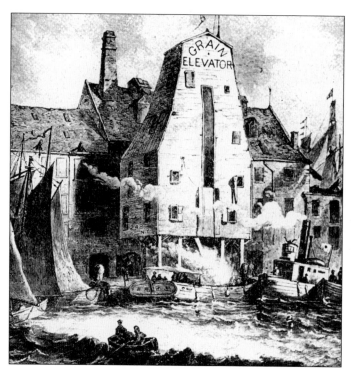

After the Erie Canal opened in 1825, the American continent poured its produce into the holds of ships docked in New York port. Here, the Morgan grain elevator in Brooklyn's Atlantic Basin, just off Buttermilk Channel, is enveloped by smoke and grain dust. Well into the 20th century, the East River continued its association with pursuits that reached back into its earliest days: grain milling and sugar refining. (Courtesy GAHS.)

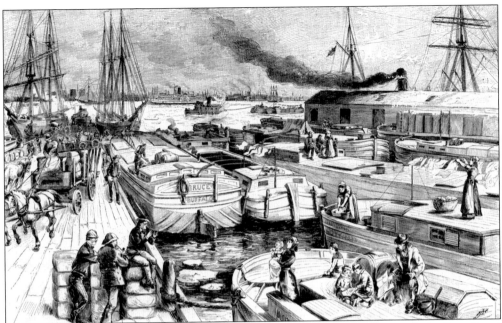

Canal boats, seen here in 1884, were the great workhorses on the river and the Erie Canal system, in which they would be towed by mules to the Great Lakes. In the winter when the rivers froze, canal boats, often homes for the captain's family, were tied up along the East River. (Courtesy GAHS.)

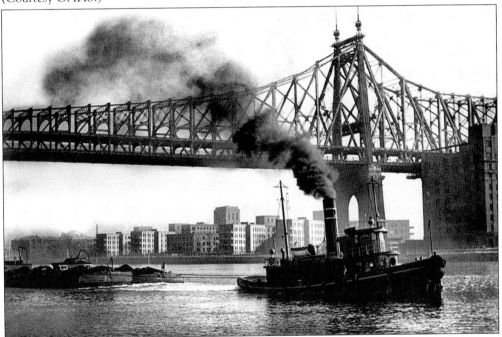

If poets and artists celebrate the Hudson, this image shows the gritty reality of the East River. Towing barges past the institutions of Welfare Island, a belching tugboat chugs under the Queensboro Bridge c. 1950. These boats, the workhorses of the 20th century, did everything from pulling barges of coal or trash to helping ships in and out of their berths. (Courtesy GAHS.)

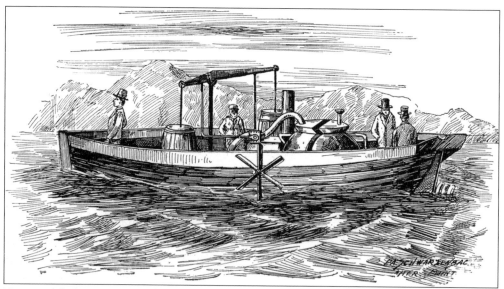

No original plans survive, so we are uncertain if the steamboat was invented by John Fitch or Robert Fulton. Accounts of those witnessing the first steamboat record they were thunderstruck that human ingenuity, surpassing the power of muscle, had finally overcome the uncertainty of wind and current. Steam power forever revolutionized maritime travel. (Courtesy GAHS.)

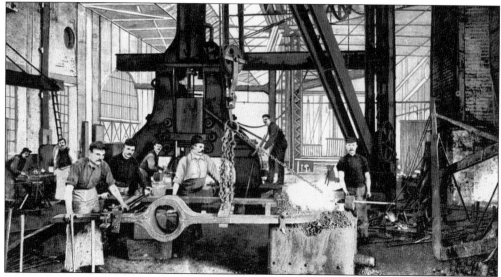

Although innovations such as the iron hull and screw propeller were tried first in Great Britain and France, the American genius for experimentation and innovation was legendary. The ironworks on the East River led the way in metallurgy and machinery design. Here, foundry workers at the Brooklyn Navy Yard forge components for a high-pressure steam engine. (Courtesy Stephen Leone.)

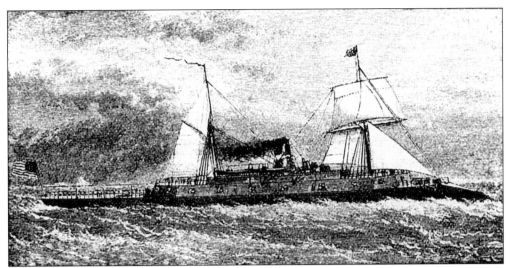

The great 19th-century wooden men-of-war built at the Brooklyn Navy Yard were made obsolete by Greenpoint's *Monitor*, assembled only a mile away. Ship design was in a state of flux, as seen with this vessel, the ironclad ram *Dunderberg*. Featuring both steam and sails, it was clumsy and unwieldy but was a step in a process that led to the great dreadnoughts of World War I. (Courtesy GAHS.)

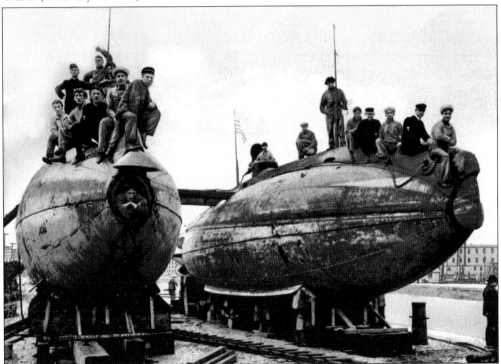

The aircraft carrier and submarine, two naval vessels that revolutionized 20th-century warfare, are connected to the East River. John Bogert of Flushing is credited with inventing an early version of the "flat-top" in 1917. The first submarine, called the *Turtle*, unsuccessfully attacked a British ship in the harbor in 1776. Here, the submarine boats *Porpoise* and *Shark* winter at the Brooklyn Navy Yard. (Courtesy Bob Stonehill.)

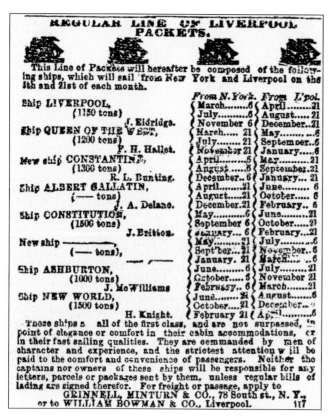

By 1830, eight different packet ships were advertising the lucrative New York-to-Liverpool run. The concept of a regular shipping schedule, in which ships would sail rain or shine, full or not, originated in New York in 1818. When people discovered they could travel abroad for the first time on a regularly scheduled basis, this bold concept became an immediate sensation. (Courtesy GAHS.)

The East River Post Office used this cancellation stamp prior to the Civil War. As post roads spurred highways, and the Pony Express the transcontinental railroad, government mail subsidies created an incentive for regular shipping schedules to Europe. When the American government withdrew financial support, mail packets, an American invention, shifted to English ships. (Courtesy Robert Singleton.)

The *Rainbow*, typical of the clipper ships built in New York during their golden age (1845–1860), was rigged for maximum sail area and designed for speed, with its sharp hull design. Unfortunately, far too many were built, and burdened with small cargo holds, the design was considered uneconomical by the 1860s. The ships were sold to foreign ports, ending their lives as battered hulks hauling lumber or guano. (Courtesy GAHS.)

Born in Rhode Island, whaling captain and merchant Preserved Fish exhibited the intrepid, fearless spirit of those men of iron who led their tall ships to the ends of the earth in the pursuit of trade. Much of the enterprising spirit of the East River's counting houses came from New England Puritan stock drawn to the East River, where opportunities were unequaled. (Courtesy GAHS.)

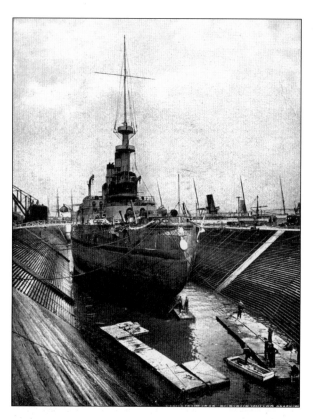

The Brooklyn Navy Yard was the largest naval facility in the country, employing more than 70,000 during World War II, with six dry docks, eight piers, hundreds of buildings, and more than 40 miles of streets and rails. During the yard's 165-year life, dozens of ships were built and thousands more repaired here. At one time, it was the largest industrial facility in New York. (Courtesy Bob Stonehill.)

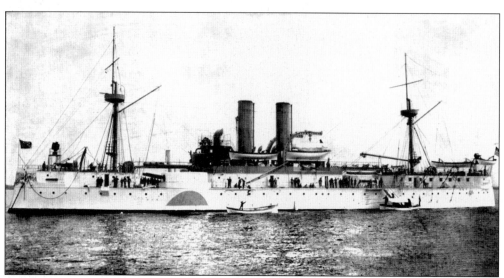

The USS *Maine*, launched at the Brooklyn Navy Yard in the 1890s, was part of the new American navy, which was soon to be a two-ocean power. The ship's destruction, in 1898 at Havana Harbor, started a series of events leading to the Spanish-American War and, ultimately, the rise of the United States as a world power. (Courtesy GAHS.)

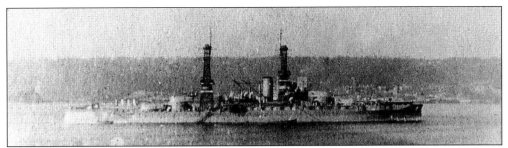

Launched at the Brooklyn Navy Yard in June 1915, the USS *Arizona* was captured on film a year later at San Diego by George Albrecht of Astoria. During the 1930s, the ship was refitted with new conning towers. It never saw action except for training cruises. The *Arizona* was destroyed, with the loss of 1,177 men, in the Japanese attack at Pearl Harbor on December 7, 1941. (Courtesy Louis Mancuso.)

The USS *Missouri*, seen here at its 1944 launch, was the last battleship built at the navy yard. The Japanese surrender, ending World War II, was signed on its decks in Tokyo Bay. In later life, the vessel saw action in the Persian Gulf. Today, the *Missouri* is permanently anchored near the Arizona Memorial at Pearl Harbor, Hawaii. (Courtesy Naval Historical Center.)

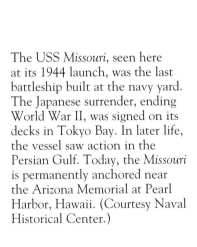
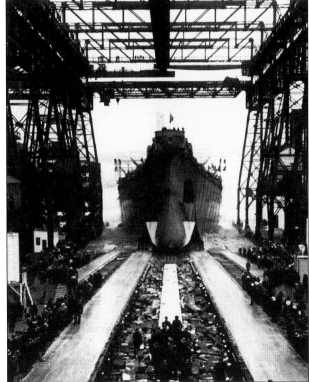

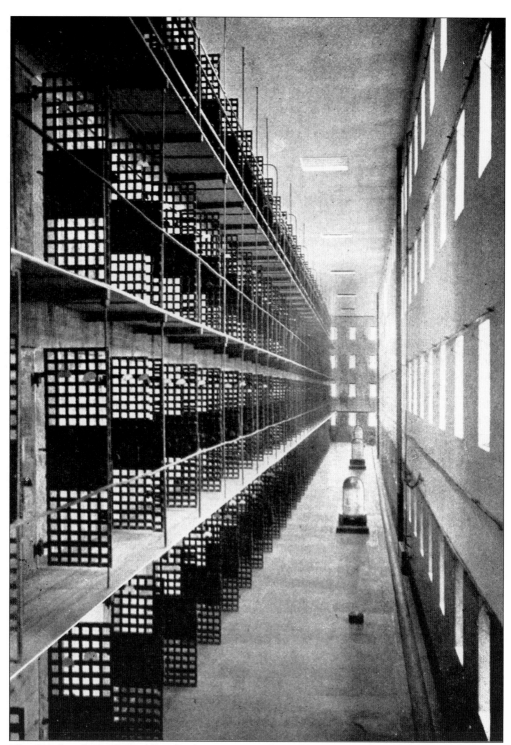

The 600-foot-long Blackwells Island penitentiary housed nearly 1,000 prisoners. Each cell bore a card with the inmate's name, age, crime, date of conviction, term of sentence, and religion. In 1932, the prison site was moved upriver to Rikers Island. (Courtesy Robert Singleton.)

Seven

INSTITUTIONS

Over time, the East River became a repository not only for industrial waste but also for what was considered social pollution. Its largest island, Blackwells (now Roosevelt), was once called Welfare Island as a reflection on the number of institutions within its narrow confines.

Impoverished single mothers, orphans, juvenile delinquents, hardened career criminals, the mentally ill, and those infected with contagious diseases have all been isolated upon islands in the East River. Even Mae West found herself serving eight days as a prisoner on Roosevelt Island in 1927 for scandalizing the delicate sensibilities of New York City in her play *Sex*.

Not all was afoul on the East River. Though best known for quarantining Typhoid Mary before she could further spread the disease of her moniker, North Brother Island was also home to Fordham, Columbia, and City College students when dormitories overflowed with young World War II veterans hitting the books. These young men were often the first in their families to get a higher education, thanks to the GI Bill. The Floating Hospital, conceived in 1866 as a way to provide *New York Times* newsboys with "fresh sea air" and basic medical services, spent its final maritime years moored near Wall Street, at Pier 11 on the East River.

Another presence, though no longer strongly felt on the river, was that of the military. After the Revolutionary War, forts were constructed on Governors Island and at the East River's mouth on the Long Island Sound to defend both New York City's economic heart and the Brooklyn Navy Yard. That island's darkest days were during the Civil War, when it was a miserable prison for Confederate soldiers. Governors Island, now managed by the National Park Service, later served as the Coast Guard's largest installation.

The East River has repeatedly been New York City's most unrelenting jailhouse guard. Prisons and juvenile detention centers have dotted all of the larger islands of the East River: Roosevelt, Wards, Randalls, and Rikers. Only Rikers Island remains a prison today, the largest in the country. More than 15,000 inmates are held on its 400 acres and converted Staten Island ferries moored alongside it. The institution is so massive that it has its own houses of worship, a post office, schools, clinics, and grocery stores.

Perhaps the most poignant story is that of the mentally ill held on Blackwells and Wards Islands in the 19th century. Staff abuse and the vermin-infested surroundings were just several of the indignities documented by intrepid investigative reporter Nellie Bly during her 10 days in the Blackwells Island Lunatic Asylum. The Manhattan Psychiatric Center remains active on Wards Island, and other mental health centers line the river, including the Kirby-Forensic Psychiatric Center and the Whitney Psychiatric Clinic.

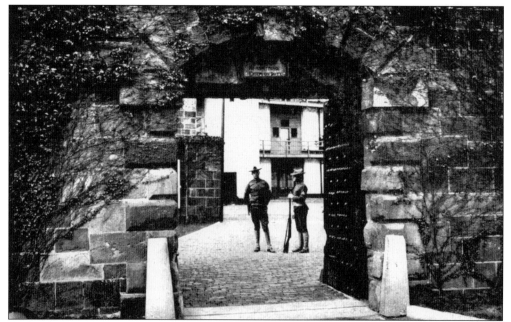

An imposing semicircular fort built of red sandstone and constructed between 1807 and 1811, Castle Williams on Governors Island watches the southern approach to the East River. Its three rows of cannon have never fired a shot in anger. During the Civil War, it was a prison for Confederate officers. (Courtesy GAHS.)

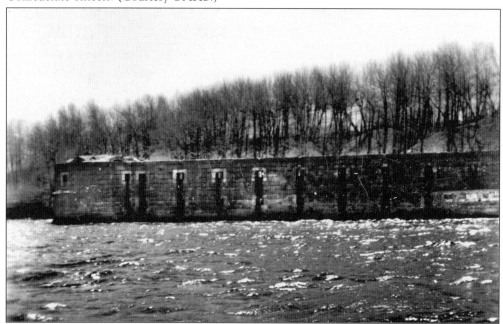

Bayside's Fort Totten, along with Fort Schuyler in the Bronx, guards the river's northern gate. It was activated in 1862 with plans prepared by Capt. Robert E. Lee. Located on Willets Point, it was named for Joseph Gilbert Totten, a military engineer. The fort was home to the Army Corps of Engineers, whose castle logo was supposedly inspired by the officers' club. (Courtesy Robert Biliski Jr.)

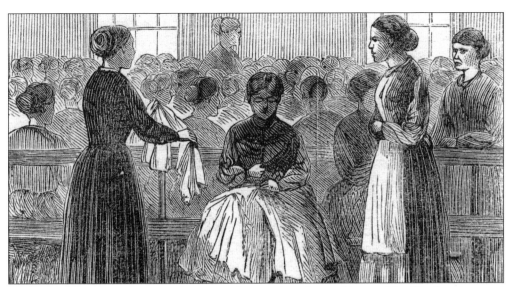

In the 19th century, the prevailing attitude was that the problems of health, housing, and unemployment afflicting the poor resulted from moral deficiencies. Rehabilitation occurred through hard work. Female inmates, classified as crippled or demented, sewed and knitted for institutions on Blackwells Island. (Courtesy GAHS.)

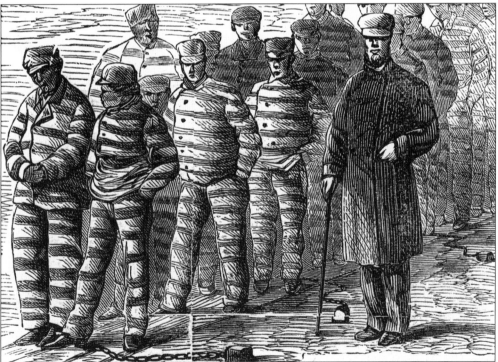

Male convicts in the Blackwells Island penitentiary were required to follow some trade or occupation. A large number cut stones in the island's quarries or did mason work on the buildings. Although nearly half of the inmates were laborers or "cartmen," others such as blacksmiths, butchers, masons, painters, and tailors plied their trades within the prison community. Most terms lasted three to six months. (Courtesy GAHS.)

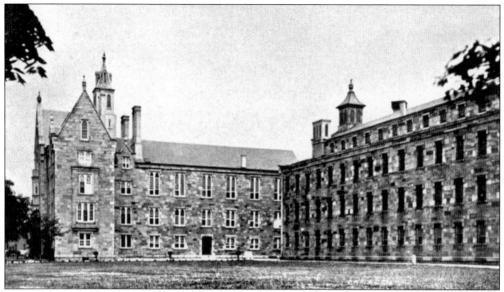

The Blackwells Island workhouse was intended to be an institution for the punishment of petty criminals. Most of the 20,000 inmates committed yearly belonged to the class known as "drunks." Many of them were repeat offenders who had become almost permanent residents. (Courtesy GAHS.)

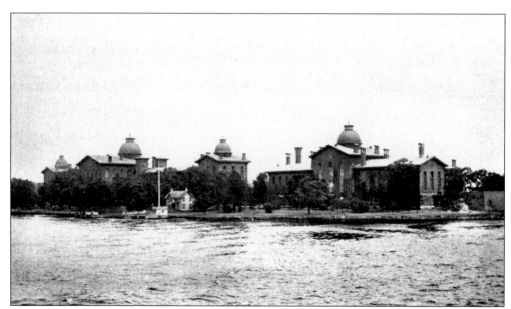

The House of Refuge on Randalls Island was a reform school for juvenile delinquents of both sexes. The two main buildings housed a population of 1,000 inmates who were taught useful trades. (Courtesy GAHS.)

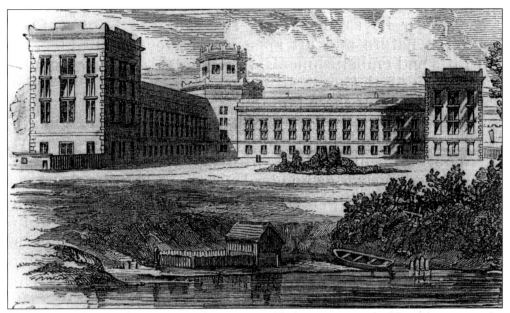

The Blackwells Island Lunatic Asylum comprised three separate buildings known as the "Asylum," the "Mad-House," and the "Retreat." In 1887, reporter Nellie Bly feigned mental illness to gain admittance into the asylum. After friends obtained her release, her exposé on the asylum's conditions led to reform. The 1839 Octagon Tower, in the center of this image, still stands today. (Courtesy GAHS.)

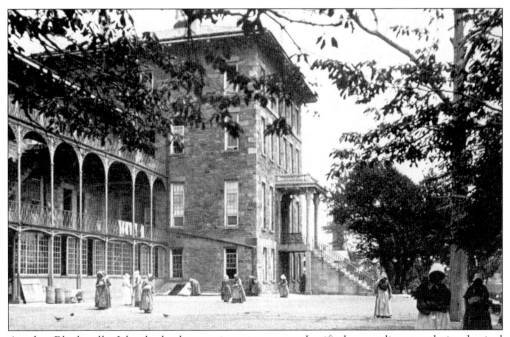

At the Blackwells Island almshouse, inmates were classified according to their physical conditions and then put to work accordingly. To ensure "proper sanitary conditions," all inmates were mandated to bathe monthly. (Courtesy GAHS.)

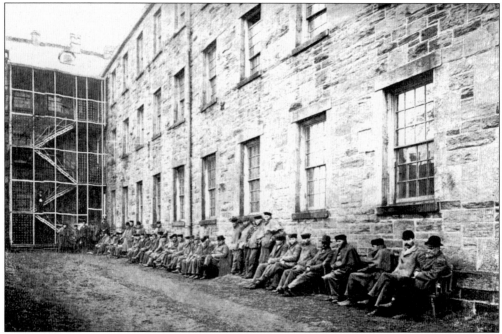

Before the opening of the Blackwells Island Tuberculosis Infirmary in 1902, consumptives were mixed with the general hospital population, thus causing a greater risk of contagion. This specialized hospital, with nearly 450 patients, was designed to minimize this risk. (Courtesy GAHS.)

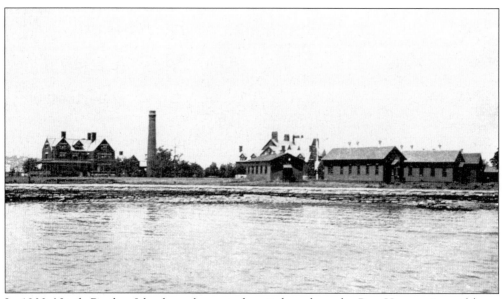

In 1900, North Brother Island was home to hospitals such as the Pest House, pictured here, housing patients with contagious diseases, most notably tuberculosis, typhoid fever, and smallpox. For 26 years, "Typhoid Mary" Mallon was quarantined on the island. It later served as a facility for drug-addicted youth. When this program ended in 1964, the island was abandoned, evolving into a bird sanctuary with vine-covered ruins. (Courtesy GAHS.)

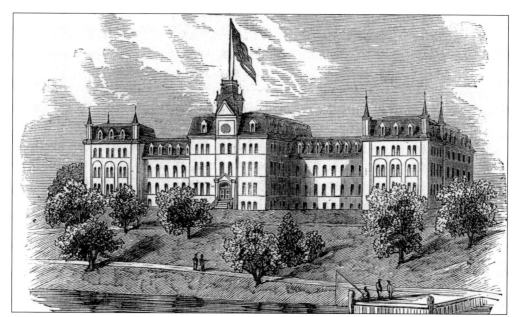

As its name suggests, the Immigrant Hospital on Wards Island was used for quarantining new arrivals. Immigrants thought to be ill or contagious were kept here until given a clean bill of health to enter society. Wards Island has been home to various institutions, including a potter's field, an immigration station, a city mental asylum, and a sewage-treatment plant. (Courtesy GAHS.)

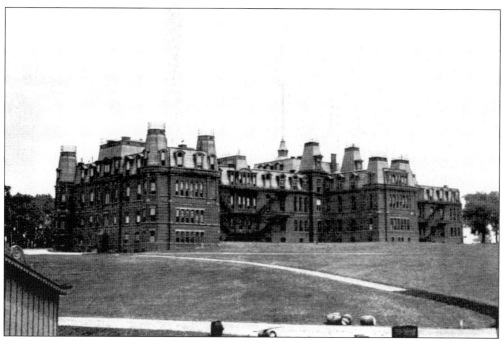

The Infant's Hospital on Randalls Island, established in 1869, cared for orphan and foundling children less than two years of age. Another ward refuged destitute mothers with babies less than two years old. By 1903, the institution had 300 cribs and an average daily census of 150 inmates. (Courtesy GAHS.)

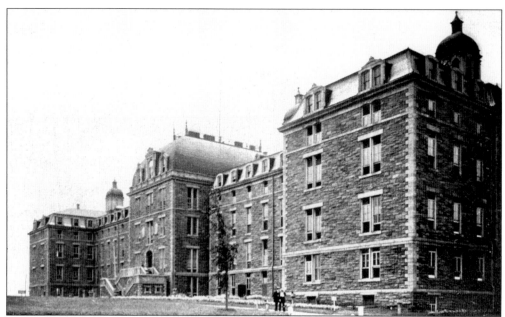

Island Hospital was built on the southern end of Blackwells Island in 1832 to provide general health care. After burning in 1858, it was rebuilt and, in 1892, renamed City Hospital. Deemed inadequate to serve New York's growing population, it was removed to Queens in 1957, becoming City Hospital Center at Elmhurst. (Courtesy GAHS.)

Metropolitan Hospital was established on Wards Island in 1875 and moved to Blackwells Island in 1894. It was the largest hospital in the country, with more than 1,000 patients suffering from both acute and chronic diseases. Attached to the hospital was the Metropolitan Training School for nurses. (Courtesy GAHS.)

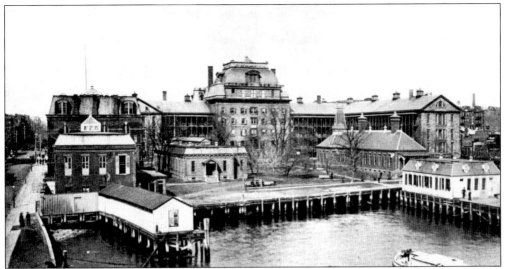

Bellevue Hospital, seen here in 1879, opened in 1736. It was the first hospital in the country to use hypodermic syringes, and the first to develop a hospital-based ambulance service. Until the late 20th century, it was the largest hospital in the city, with a total of 2,700 beds. It also functions as the city morgue. (Courtesy GAHS.)

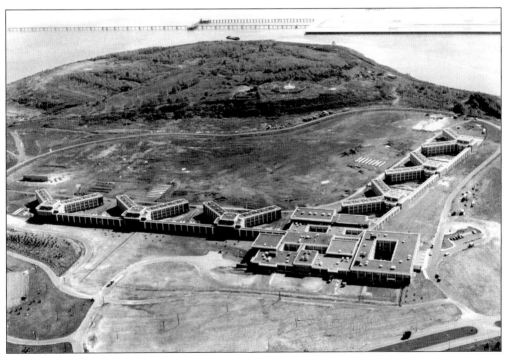

The Adolescent Reception and Detention Center opened in 1972. The facility houses male detainees aged 16 to 18, with a capacity of 2,500. For decades, the cultivated woodland (ex-landfill) has supplied trees and shrubs for the parks department and given inmates opportunities for job training in tree planting and maintenance. In the upper part of the image, the end of a LaGuardia Airport runway is visible. (Courtesy NY Correction History Society.)

Although East River Park c. 1900 was a public space, tenement children were often told by police they could not play in it. Today, this land contains Carl Schurz Park and Gracie Mansion. The modern "East River Park" refers to the recreation area near Houston Street and the FDR Drive. (Courtesy GAHS.)

Eight

RECREATION

It is difficult for some people to imagine that hundreds of years ago the East River was pristine and wriggling with healthy fish. It is even harder to imagine that within living memory people swam in the East River as a matter of course. Even today, the East River is popular with anglers, though warnings against eating their catch abound.

The river was the front yard and commons for many of New York City's neighborhoods. Residents splashed in the East River from Brooklyn to the Bronx as swimmers in summer, and scraped along the icy surface of its coves as skaters in winter. Lean rowers powered sculls in neighborhood racing clubs. Long before swimmer safety was centralized by the New York City Parks Department and the U.S. Coast Guard, local volunteer lifeguards watched its shorelines.

The waterfront was a lifeline for poor immigrants. Just as city and state parks departments are today constructing greenways along the waterfront, their predecessors built squares and piers free of urban grit and grime. The need was enormous in the early industrial age, when coal soot rose from stacks all around town and from ships in the harbor, and there was no cheap and easy transportation out of the city. Churches often arranged day trips away from the squalor aboard ferries destined for resort complexes in Clasons Point in the Bronx or College Point in Queens. It was on one such bright day in 1904 that the *General Slocum* caught fire, killing more than 1,000 people (mostly women and children) from the Lower East Side's community of German immigrants.

The waterway's decline as a place of recreation might be attributed to a landlubber: the automobile. Robert Moses paved Manhattan's beaches, inlets, and bays under the FDR Drive while designing great public works to be accessible only by car. The long forgotten Jones's Wood waterside park in Manhattan was reborn in a sense as the traffic-clogged Jones Beach on Long Island. As industry continued to foul the waters, there was little incentive for middle-class and wealthy New Yorkers to linger by the East River. A vicious cycle was set into motion— with affluent New Yorkers turning their backs on the East River, environmental abuses could ratchet up.

By 1997, the idea of swimming in the East River had devolved into a punch line on television's popular situation comedy *Seinfeld*. Ironically, that show was taped in Los Angeles while New York's rapidly expanding film and television industry deepened its roots along the East River waterfront. The legendary Kaufman-Astoria Studio and expanding Silvercup Studios are sited near the water, and the industry has made bids for other East River locations, including a grand plan to transform the Brooklyn Navy Yard into a new center of silver screen arts.

From Brooklyn and the Battery, to College Point and the Bronx River, another generation is discovering the new "Heart of New York."

At Third Avenue and 110th Street, a smart fisherman could take home several fish an hour while angling off a bridge over the Harlem Meer, a creek off the Harlem River. A nearby reef in Hell Gate, called Hog's Back, was considered one of the great spots in New York for bass, as they would congregate by the rock, rubbing their backs on it as they fed. (Courtesy GAHS.)

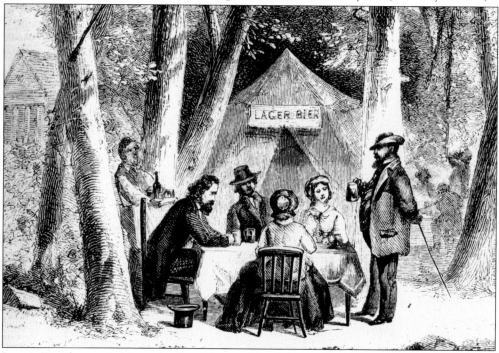

Jones's Wood extended from the East River to Third Avenue between 66th and 75th Streets. It attracted church groups and private clubs for outings with its beer saloons, dance halls, and bowling alleys. When it was suggested as a site for Central Park, local residents argued that they did not want a large park in their neighborhood. The city's growth led to the area's demise in the 1890s. (Courtesy GAHS.)

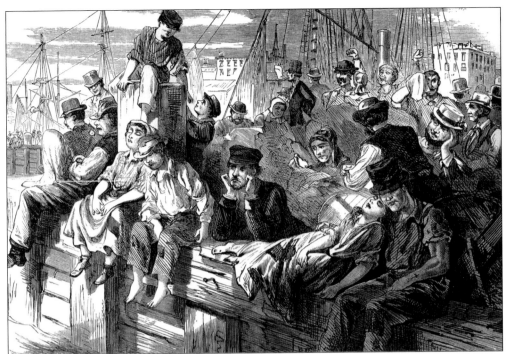

Tenements emptied onto the docks when summer heat made windowless rooms unbearable. Sweltering summers were dangerous for those living in apartments that often had no air shafts or windows. Newspaper accounts of the time had stories of dogs going mad, horses suddenly dropping dead in their tracks, and restless throngs stepping over mattress-strewn sidewalks. (Courtesy GAHS.)

Offering cool breezes and open spaces, docks were a dangerous magnet for children, often frustrating the efforts of ministers and politicians to clean up the docks. It is hard to tell if these boys are playing an innocent game of marbles or shooting craps. A newspaper account in 1912 stated one youth won $18 in an afternoon—not bad when this was a week's salary. (Courtesy GAHS.)

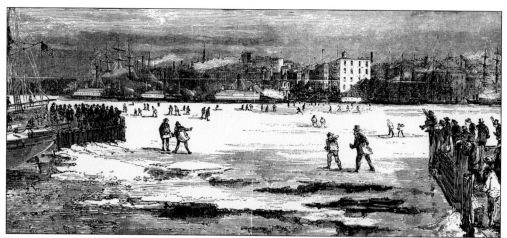

In the 19th century, frigid winters froze solid New York's rivers and bays. There are stories of people skating from New Jersey across the Hudson, through Manhattan, along today's Canal Street, to the East River, and on to Brooklyn. (Courtesy GAHS.)

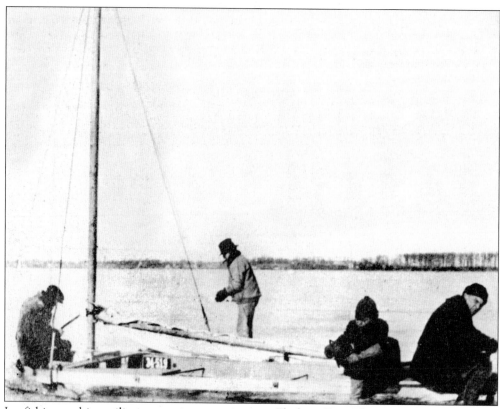

Ice-fishing and ice-sailing were winter pastimes on Flushing Bay. There are accounts of sleds traveling from the Bronx across the East River to Queens on thick ice. (Courtesy GAHS.)

William H. Rydberg, shown with his wife, Elvira, and daughter Ruth, takes a break from swimming in the East River c. 1926. In the background is the Hell Gate Bridge viaduct on Wards Island. These Astorians sought the refreshing breezes and cool waters of the river. (Courtesy Ruth Meyerhoff.)

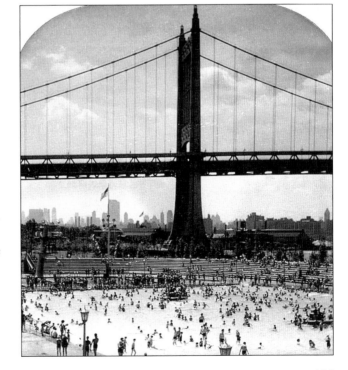

With Manhattan in the background, the new Triborough Bridge towers over swimmers at Astoria Pool c. 1940. Athletes dive into the pool, glimpsing the East River on their descent. The site of Olympic trials in 1936 and 1964, it was constructed at a cost of $1.5 million and could accommodate 8,500 bathers. (Courtesy Robert Singleton.)

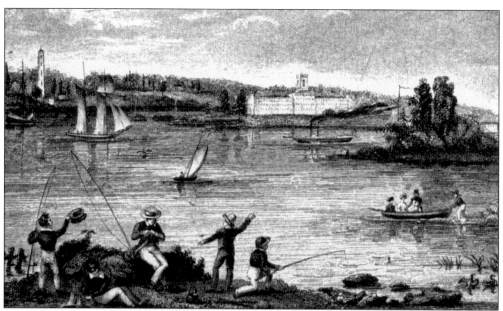

Entitled "Uncle Philip's Fishing Party," this convivial group set its poles in the mouth of Newtown Creek *c.* 1835. The creek is crystal clear, with flounder and porgies. In the foreground is Greenpoint, Brooklyn, while in the distance are, from left to right, Sutton Place, Blackwells Island, and Hunters Point. The steamboat is the Flushing ferry. (Courtesy GAHS.)

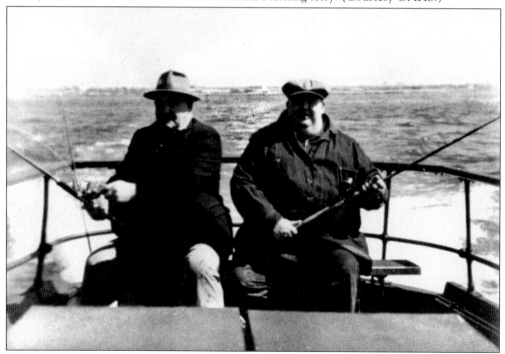

Henry Biliski (left) and "Big Ben" Biliski of the Bowery Bay Boat Club set their fishing poles into the East River on a wintry day in the 1940s. Today, bluefish, blackfish, and striped bass are still found in the East River, and favorite fishing spots are off Belmont Island, Pot Rock, Wards Island, and in various deep troughs in the Hell Gate. (Courtesy Robert Biliski Jr.)

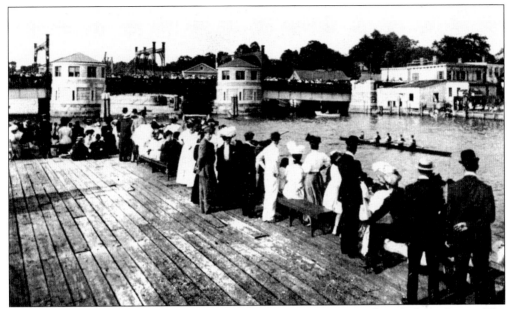

In 1900, throngs of onlookers watch a rowing competition on the Flushing River. The Wahnetah Oarsmen were a champion team located near the Flushing Bridge. Competitions were held on the East River and Long Island Sound against rowing teams from around the country. (Courtesy GAHS.)

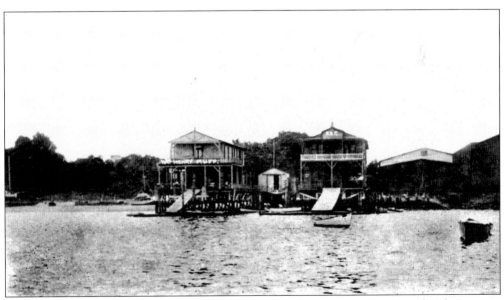

The Ravenswood Boat Club, founded in 1882, was headquartered at the foot of 38th Street in Long Island City. Many boat clubs in Queens were destroyed when the Grand Central Parkway all but cut off public access to the waterfront. The Ravenswood group disbanded sometime before 1956. (Courtesy Eric Pitfick.)

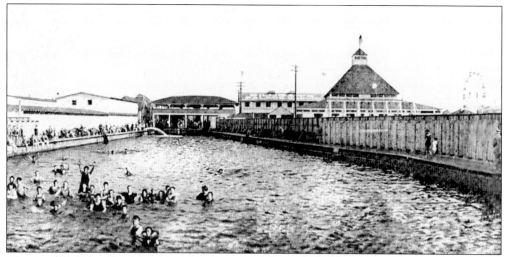

Clasons Point's proximity to the East River and the mouth of the Bronx River led to resort development that included dance halls, bathing piers, and restaurants. In the early 1920s, the pool at Clason Point Amusement Park had water so dark it was called the "Inkwell." (Courtesy Bronx County Historical Society Research Library.)

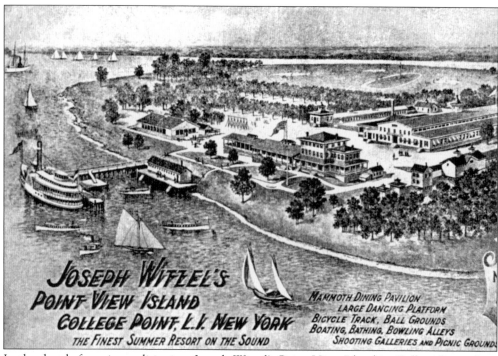

In the days before air-conditioning, Joseph Witzel's Point View Island in College Point drew crowds of people from Manhattan, the Bronx, and Queens. Jutting out into the East River, this summer resort owned by a local businessman offered every type of entertainment, including boating, bathing, and picnic grounds. Sadly, today a sewage treatment plant is located on these grounds. (Courtesy Poppenhusen Institute.)

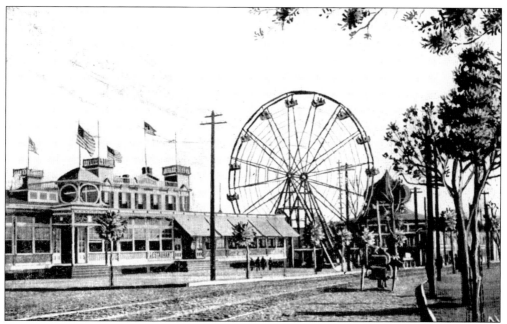

A partnership between Henry Steinway and George Ehret, North Beach Amusement Park was built in 1886. It featured a midway with rides, dancing halls, musical entertainment, aquatic shows, beer gardens, boating, and bathing. Today, the runways of LaGuardia Airport bisect the midway of North Beach. By 1920, Prohibition had spelled its doom. (Courtesy Bob Stonehill.)

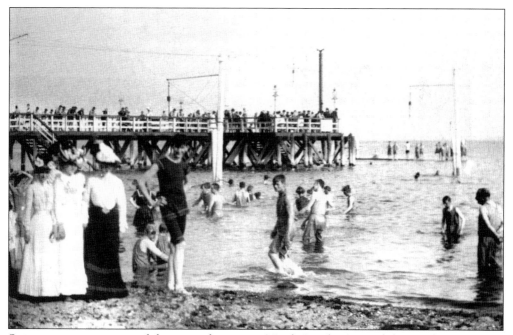

Swimming was just one of the many features at North Beach. Accessibility to the waterfront gave many people the opportunity to enjoy the East River. This pier burned in a spectacular fire in 1925, and the site became Glenn Curtiss Airfield and, later, LaGuardia Airport. (Courtesy Vincent Seyfried.)

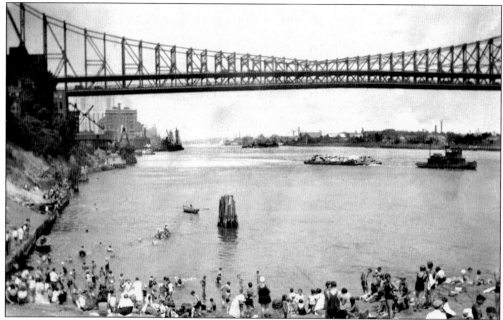

In the 1920s, bathers at "Sutton Beach" on the East River, just south of the Queensboro Bridge, seem oblivious to the tug towing a garbage scow. On a hot day, the East River was an inviting place to stay cool. Today, this location is under the FDR Drive. (Courtesy Roosevelt Island Historical Society.)

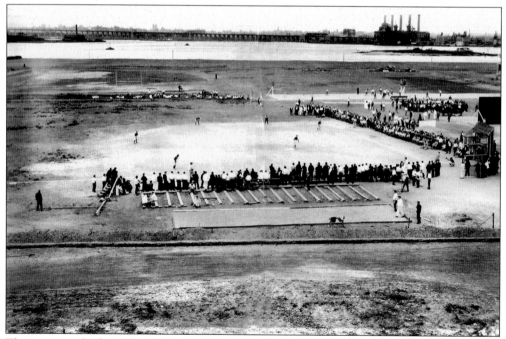

The inmates of Rikers Island enjoy an afternoon of America's favorite pastime on the shores of the East River. Rikers Island is all but barren in this mid-1930s photograph. The Brother Islands can be seen in the distance. In the far distance are the Port Morris rail yards and power plant. (Courtesy NY Correction History Society.)

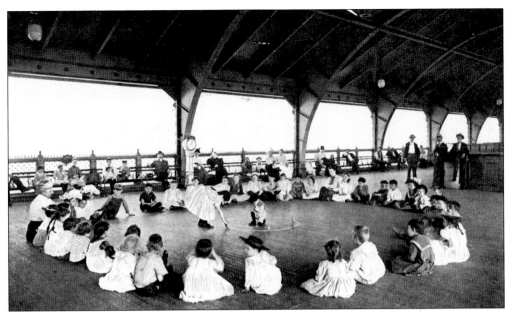

A kindergarten class meets on a new recreation pier on 24th Street, just north of what was once the notorious Gas House District. Social reformers suggested these piers as a wholesome place for fresh air and family fun. Throngs flocked to them for community events such as band concerts. Some piers were up to 700 feet long. (Courtesy GAHS.)

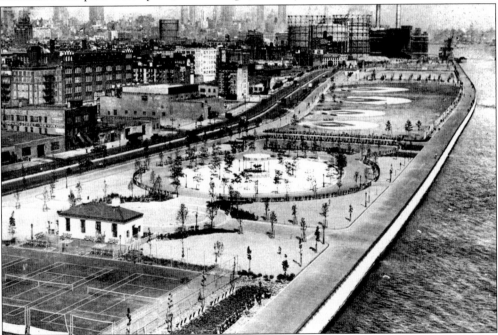

Sidney Kinglet's classic *Dead End* (1937) portrayed the East River waterfront as a bedraggled, grimy mass of factories, coal yards, and decaying docks. To change this image, local elected officials and the federal government partnered to allow public access. In 1939, this park opened, transforming the East River from Grand to 14th Streets into a playground and park. (Courtesy NYC Municipal Archives.)

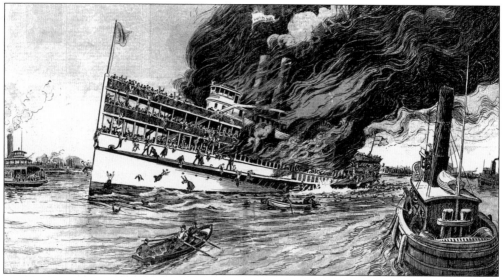

Church groups and social clubs of every description rented boats for daytime excursions to North Beach, College Point, Clasons Point, and destinations farther east on the Long Island Sound. Although safety regulations were in place, lax enforcement made them all but useless. One of the most popular vessels, the *General Slocum*, caught fire on June 15, 1904, killing more than 1,000 people within a few hundred feet of shore. (Courtesy GAHS.)

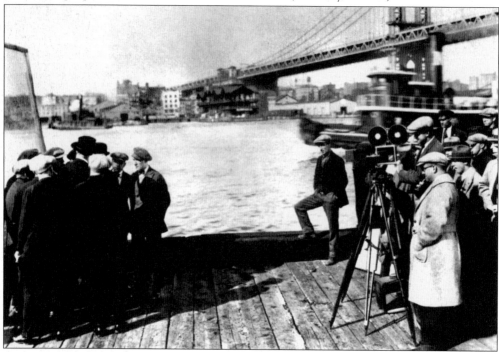

The East River has provided a spectacular backdrop for the movie industry, from the silent era until today. *Big Brother* (1923) was the story of Lower East Side gang warfare shot on location, with the Manhattan Bridge and ferry terminal in the background. Movie and television references to the East River have been overwhelmingly negative. Its checkered past has suggested mob-related and criminal activities—real or imagined. (Courtesy Kaufman-Astoria Studios.)

Pictured here in 1916, the Clason Point Volunteer Life Saving Association was one of several volunteer groups stationed along the East River whose duty was to rescue drowning swimmers and save disabled boats. The association's work was later assumed by the Coast Guard. (Courtesy Bronx County Historical Society Research Library.)

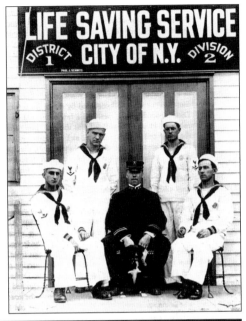

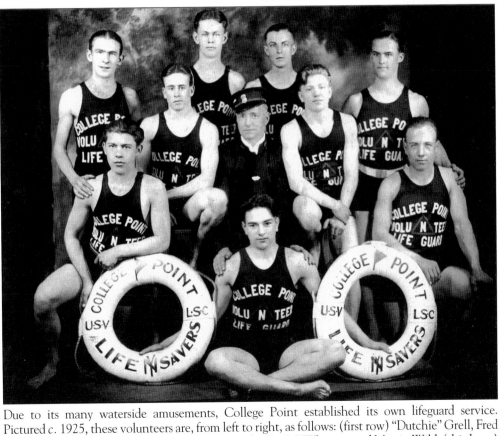

Due to its many waterside amusements, College Point established its own lifeguard service. Pictured c. 1925, these volunteers are, from left to right, as follows: (first row) "Dutchie" Grell, Fred Krell, and Lou Emmerich; (second row) ? Bop, Bob "Cap'n" Whitten, and Martin Wild; (third row) Frank Philip, Arthur Hunter, Fred Mahler, and Ray Pitt. (Courtesy Poppenhusen Institute.)

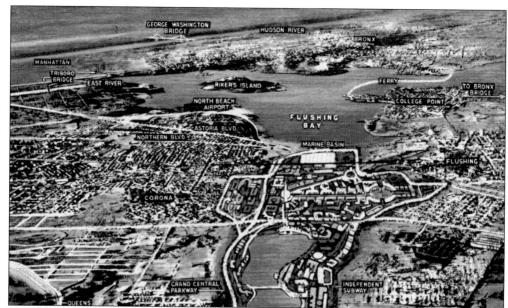

The Flushing Meadows World's Fair of 1939–1940 rose out of the Corona Dumps after $59 million of permanent improvements. Despite 44 million attendees, the fair was not a financial success. It was beset by the politics of the time; World War II started just after it opened. However, its theme, "Building the World of Tomorrow," gave a glimpse of the happier future. (Courtesy Bob Stonehill.)

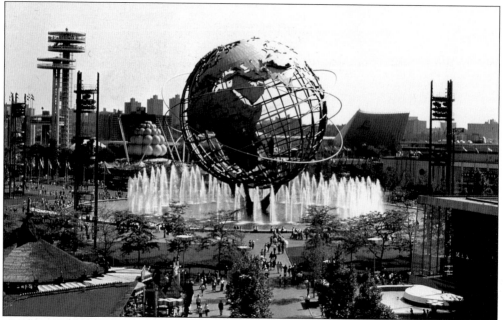

The Unisphere was the symbol of the 1964–1965 World's Fair, also held in Flushing Meadows Park. This fair's theme was "Peace through Understanding," a fitting tribute to the former home (1946–1950) of the United Nations. Although 51 million attended, like its predecessor, the fair was not a financial success. The park is now host to the U.S. Tennis Center, the Queens Zoo, and the Hall of Science. (Courtesy Bruce Dearborn.)

In 1958, the Columbia University sailing team moved to the marina in Flushing Bay, followed by Barnard College a decade later. The 1964 World's Fair expanded the marina to 850 births, making it one of the largest on the East Coast. Sailing was tricky, though, as the jet wash from planes landing at LaGuardia often caused unexpected wind shifts. (Courtesy MTA Bridges and Tunnels Special Archive.)

The captain's name of the good ship *High-Hook* is lost to history. He sailed out of Muff's Boathouse (c. 1940) at the end of Astoria's Steinway Street. Charter fishing boat captains earned their expertise through years of hard work and experience. (Courtesy Robert Biliski Jr.)

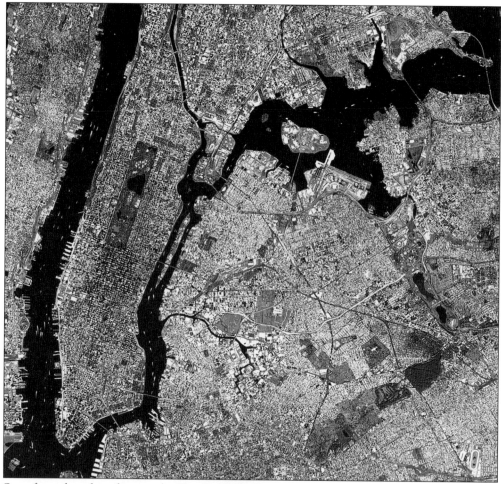

Seen from the edge of space, the East River flows as a narrow ribbon within an urban mosaic. The "Heart of New York" flows through some of the most expensive real estate in the world. Compare this map to pages 10 and 11. (Courtesy NASA.)

Nine

PERSPECTIVES

In many ways, our generation knows the East River more than any that preceded—even the Native Americans who depended upon it for food and the industrialists who altered its course forever. We can view it from space satellites as a tiny detail on a small, watery planet. With another set of instruments, we can analyze its chemical composition, biota, hydrology, and geology with nearly incomprehensible precision. Mounds of such data can help citizens become better caretakers of the strait, but only if they feel motivated by an intrinsic attachment to it.

New York's economy continues to shift away from its industrial base toward information, media, financial services, and the arts. Waterfront tracts once used for parking lots and factories are now being developed for housing. Luxury apartment towers are sprouting on the Brooklyn and Queens bank of the East River to capitalize on the skyline and harbor views. It is such an inspirational setting that American boosters want to house athletes there in an Olympic village, for the 2012 games.

However, the policymakers and investors overseeing this real estate bonanza are usually baby boomers raised in Robert Moses's automotive world, or newer arrivals with no awareness that only decades ago swimming and playing in the East River were popular activities. They have been slow to awaken to the potential of the East River as a place for enjoyment rather than mere viewing.

Residents and parkgoers along the East River cannot help but notice glimmerings of a new age at hand, one in which this waterway will become the great oasis of respite in the heart of the city. In terms of open air and variety of recreation, it could dwarf Central Park. The annual Manhattan Island Marathon Swim draws competitors from around the globe. A flowering of new community boating groups like the East River Kayak Club, the East River Apprentice Shop, Floating the Apple, East River CREW (Community Recreation and Education on the Water), Gowanus Dredgers Canoe Club, and Rocking the Boat have put thousands of New Yorkers onto the East River. Individual kayakers with skin-and-frame boats that fold into backpacks launch discreetly from points all along the water.

The recovering ecosystem is igniting passionate involvement, too. The Urban Divers reveal schooling fish hidden in the East River's depths via live video. And fishing never entirely vanished. Anglers come out in all seasons, whether to catch a meal where the Harlem River and East River meet, or as enthusiasts of the sport, idling aboard boats in the main channel. Alliances have formed to nurture the Bronx River and Newtown Creek, and the Metropolitan Waterfront Alliance is linking such groups into an East River Network.

With water quality improving year by year, it is unlikely that New Yorkers will abandon their aquatic escape so readily again. A new, unexpected sound rises from the face of the famous and infamous East River: laughter.

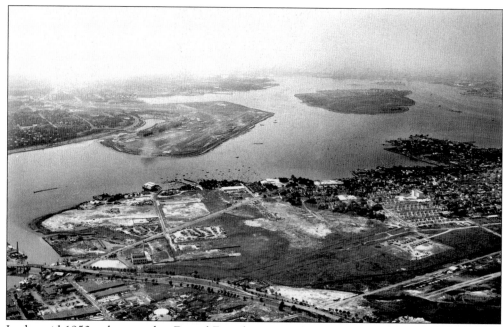

In the mid-1950s, photographer Daniel Zirinsky captured the upper East River as a shimmering body of water flowing around a soon-to-be-expanded LaGuardia Airport and Rikers Island. (Courtesy Daniel Zirinsky.)

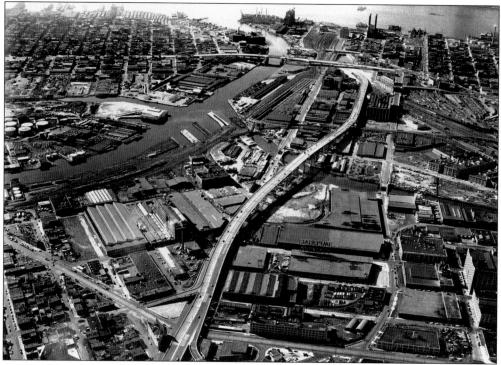

During the mid-20th century, Newtown Creek was perhaps the most concentrated industrial precinct in the country. A network of highways and railroads made it the epicenter of New York's commercial activity. (Courtesy Daniel Zirinsky.)

Much of the waterfront, once caught in a spiraling decline, is now coming back. "Reviving Williamsburg" was taken on a brisk morning by photographer Shuli Sadé during the bridge's repair process. (Courtesy Shuli Sadé.)

The roofless Tobacco Warehouse in Brooklyn Bridge Park was built in 1871 and saved from demolition in 1998. This compelling public space is a vivid reminder of the shipping activity that once defined the downtown Brooklyn waterfront. Photographer Etienne Frossard captures the beauty of this structure and the Brooklyn Bridge. (Courtesy Etienne Frossard.)

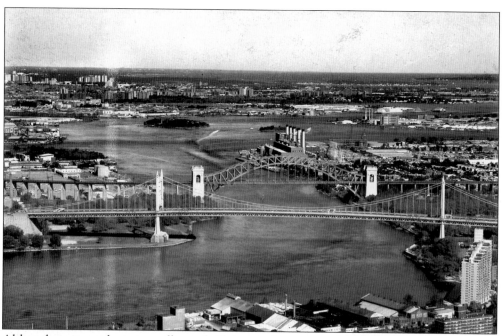

Although trains and motor traffic on bridges may hurry over the Hell Gate waterway, boats must still fight its currents and whirlpools. Despite many attempts to tame it, the Hell Gate remains the most dangerous part of the harbor. This was the perilous setting for novels by Washington Irving and James Fenimore Cooper. The Hell Gate is the stuff of legend. (Courtesy Granard Associates/F. W. Duffy.)

Bridge photographer Dave Frieder, from the top of the Manhattan Bridge, captures a day in the late 1990s on the lower river. In contrast to the crowded river scene of 100 years before (see page 50), it seems eerily quiet. A few years later, dust, smoke, and ash from the World Trade Center would obscure this view. The river remains at the vortex of world events. (Courtesy Dave Frieder.)

A tugboat pushing a barge chugs by a Queens power plant belching steam. New housing on Roosevelt Island lines the waterfront, completing this composition. Few photographers can equal, and none have surpassed, Bernard Ente in distilling the essence of the unique qualities that make up the East River. (Courtesy Bernard Ente.)

The oldest part of New York, the Financial District, has always been a tangle of noisy streets crowded with people and traffic on a typical workday. Just a few hundred feet away, in an interesting contrast, a boat glides by in its own world. (Courtesy Bernard Ente.)

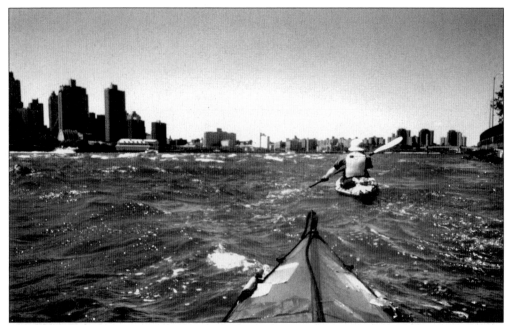

Individual kayakers with skin-and-frame boats that fold into backpacks launch from parks and dead-end streets along the waterway. Although they may be from different boroughs and have varied backgrounds, on the East River, they are citizens of one maritime neighborhood. (Courtesy Erik Baard.)

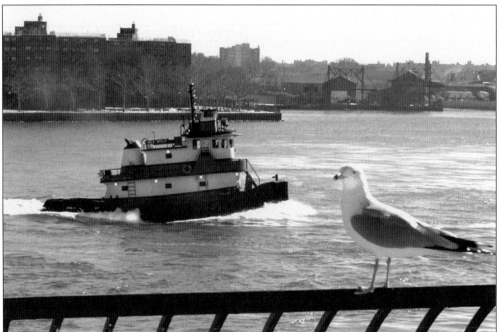

The four boroughs along the river have a combined 7.5 million people. Juggling the needs of housing and industry, and balancing it all with nature, is a formula that will always be a work in progress. In the background, Hallets Cove is visible near Old Astoria Village, an antebellum community that still strongly echoes the mid-19th century. (Courtesy Bernard Ente.)

Visitors to the esplanade in Brooklyn Bridge Park, stretching 1.3 miles along the East River, enjoy the spectacle of the John D. McKean Fireboat as it passes underneath the Manhattan Bridge. The creation of the park is part of New York City's wider waterfront revitalization and is bringing New Yorkers back to the water's edge to reclaim one of the city's greatest assets. (Courtesy Etienne Frossard.)

A swimmer competing in the 2004 Manhattan Island Marathon Swim passes the United Nations. Individual swimmers and small groups have attempted the 28.5-mile feat since 1915, but the annual event, sponsored by the Manhattan Island Foundation, did not begin until 1981. (Courtesy Erik Baard.)

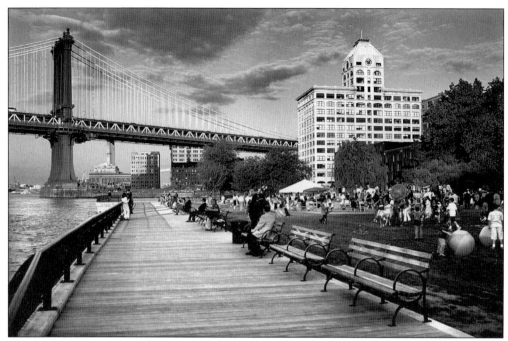

The completed portion of Brooklyn Bridge Park sits between the Manhattan Bridge (pictured) and the Brooklyn Bridge and has already become a treasured oasis. Thousands of visitors come to this spectacular setting every year for unparalleled views across the East River, as well as events such as the Film Series, Spring Fling, and the Summer Family Series. (Courtesy Etienne Frossard.)

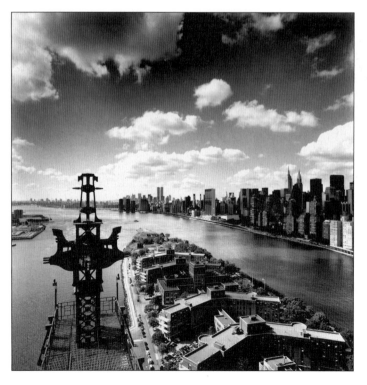

A crown from the Queensboro Bridge overlooks Roosevelt Island and the lower river. In Brooklyn, community access is important; a greenbelt is planned for the river's banks. The Bronx waterfront, once lost to industry, also has groups dedicated to waterfront conservation. Manhattan balances development with access. In Queens, with a few notable exceptions, the waterfront is given over to power plants and private developers. (Courtesy Dave Frieder.)

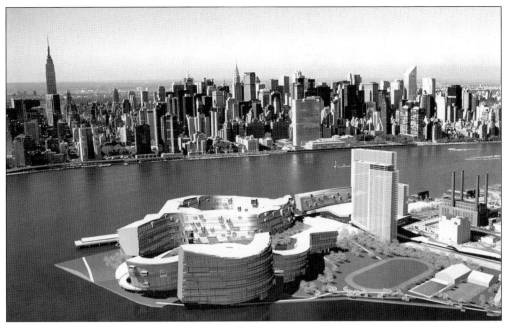

The Olympic village proposed for the 2012 games is part of a massive plan to transform the Long Island City waterfront with thousands of housing units. Waterfront development plans change frequently. For example, this image lacks the Trump Tower next to the United Nations complex. (Courtesy NYC 2012.)

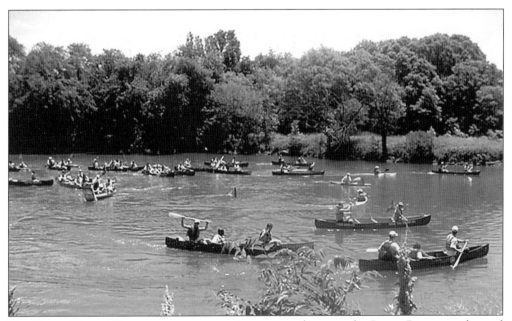

The Bronx River Alliance acts to protect, improve, and restore the Bronx River corridor and greenway. The group's mission is to make the Bronx River a healthy ecological, recreational, educational, and economic resource for the neighborhoods through which it flows. Its strength lies in the participation and independence of the communities along the river, which are so intimately connected to its past and future. (Courtesy Bronx River Alliance.)

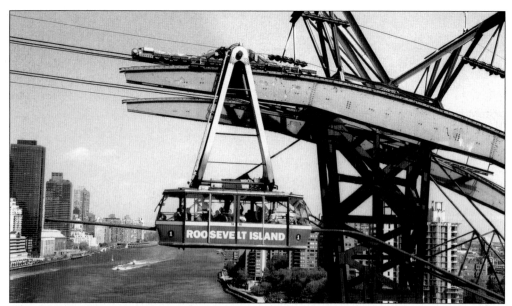

Praised by the *New York Times* as having "the most exciting views in New York City," the four-minute tram ride from midtown Manhattan to Roosevelt Island has had nearly 30 million passengers since it opened in 1976. Each cabin, with a capacity of 125 people, makes approximately 115 trips a day. At its peak, it climbs 250 feet above the East River. (Courtesy Roosevelt Island Historical Society.)

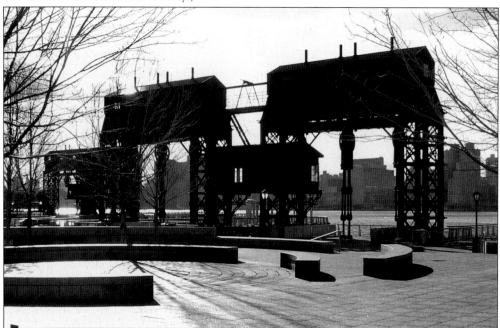

Dedicated in 1998, this two-and-a-half-acre park is located in Hunters Point. The former barge transfer gantries, where railcars were taken from barges to the Long Island Rail Road, have a new lease on life as a beautiful state park. Credit goes to Queens West Development for paying homage to Long Island City's industrial past. For an earlier view, see page 50. (Courtesy Stephen Leone.)

Socrates Sculpture Park was an abandoned riverside landfill and illegal dump site until 1986, when a coalition of artists and community members transformed it into an open studio and exhibition space and a neighborhood park. An internationally renowned outdoor museum and artist residency program, the area also serves as a vital New York City park offering a wide variety of public services. (Courtesy Stephen Leone.)

The timeless setting of Gracie Mansion, the last of the great estates that once lined the East River, is most fitting for the mayor's residence. From Peter Stuyvesant to the diplomats at the United Nations, notable people have made momentous decisions along the river's banks. But it was also on the East River that the dreams of immigrants wove the very fabric of our nation's ethos. (Courtesy Judy Shimkus.)

If the East River runs through New York's heart, then the river's midpoint, Astoria Park, is the fulcrum about which the city swirls. Here, as the sun sets behind the Triborough Bridge and a leafy bough in the park, we are reminded of an old adage: "The countryside is God's creation and towns are of man." Where they meet is the city's soul. (Courtesy Bernard Ente.)